SHEA STADIU

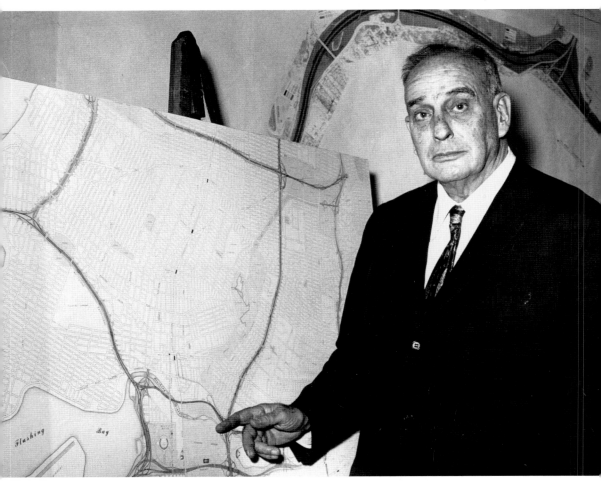

Robert Moses, the master builder of New York City, points to the location of William A. Shea Municipal Stadium, new home of the New York Mets, in this photograph from 1964. Surrounding the stadium is the territory of Flushing Meadows. (Courtesy of the Queens Borough Public Library, Long Island Division, Portraits Collection.)

On the front cover: A good luck floral piece is presented to Joe Torre by William A. Shea, the namesake for the stadium, on opening day April 7, 1978. This was Torre's first official season as the New York Mets' first player/manager. (Courtesy of the Queens Borough Public Library, Long Island Division, Illustrations-Sports/Baseball.)

On the back cover: The New York Mets are playing the Chicago Cubs in this photograph of Shea Stadium from 1986, after the ballpark underwent major renovations. (Courtesy of Carl Abraham.)

Cover background: Please see page 117. (Photograph by the author.)

SHEA STADIUM

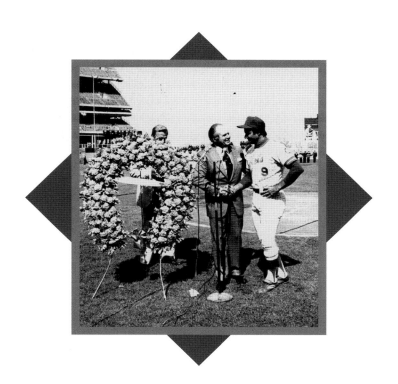

Jason D. Antos

ARCADIA
PUBLISHING

To my grandfather Milton, a diehard Mets fan who gave up his box seats

at Shea Stadium just a few months before the 1969 World Series.

Well, here is the next-best thing.

Published by Arcadia Publishing
Charleston SC, Chicago IL, Portsmouth NH, San Francisco CA

Printed in the United States of America

Library of Congress Catalog Card Number: 2007924161

For all general information contact Arcadia Publishing at:
Telephone 843-853-2070
Fax 843-853-0044
E-mail sales@arcadiapublishing.com
For customer service and orders:
Toll-Free 1-888-313-2665

Visit us on the Internet at www.arcadiapublishing.com

CONTENTS

ACKNOWLEDGMENTS

No project of any kind is the work of just one individual. As always, I thank my family and friends for their support. At the Long Island Division of the Queens Borough Public Library, I would like to thank Judith Todmann and John Hyslop. Thanks to the Olmsted Center in Flushing Meadows-Corona Park for making its little-known, but extensive, photographic archive available to me. Thanks to archives assistant Lesley Zlabinger at the Louis Armstrong House and Museum. And, as always, thanks for the support and assistance of Richard Hourahan and James Driscol at the Queens Historical Society.

I would also like to thank Mets fans and the "the New Breed." We truly are the best fans in baseball.

And finally, I would like to dedicate this book to the young historians and writers of New York City who will hopefully use this book in the years to come to learn about Shea Stadium and its surrounding neighborhoods, which are located in a city whose landscape is forever changing and renewing.

INTRODUCTION

In 1907, Michael Degnon, builder of the Williamsburg Bridge and part of the Interborough Rapid Transit Company (IRT) subway, began buying up every tract of salt meadow along Flushing Creek. He thought by doing this he would be able to build a port facing Flushing Bay and the federal government would pay for his plan to make the bay accessible for large cargo ships, which would have turned the area into a major trading post. He began buying ashes and refuse and dumping these onto the salt meadows to lay a foundation. These immense piles of dirt and soot were immortalized in F. Scott Fitzgerald's book *The Great Gatsby* and became known to the world as "the Valley of Ashes." Fitzgerald describes it as "a fantastic farm where ashes grow like wheat into ridges and hills and grotesque gardens."

The dumps remained an eyesore until 1937, when Robert Moses cleaned them up in anticipation for the 1939 world's fair. The site was used again for the 1964–1965 world's fair and would later become known as Flushing Meadows-Corona Park. With the land cleared, the Valley of Ashes became just a horrible memory for local residents.

The motion for a stadium to be built in Queens predates the New York Mets and Shea Stadium by almost a quarter of a century. In November 1940, the Chamber of Commerce of the Rockaways in Queens and its president Andrew J. Kenny began petitioning the City of New York to build a venue that could be used for sports and entertainment somewhere in the vicinity of the 1939 world's fair and Flushing, which is the borough's main financial district. The second motion for a stadium came in 1956, when Brooklyn Dodgers president Walter O'Malley asked for improvements to be made to Ebbets Field. The city offered him a new park in the Flushing Meadows area. O'Malley denied this proposal: "If the Brooklyn Dodgers move to Queens, than they are no longer the Brooklyn Dodgers." As a result, in 1957 the team moved west to Los Angeles along with the New York Giants, who moved to San Francisco.

That same year, New York attorney William A. Shea was approached by Mayor Robert Wagner to begin a new project. His mission: to return a National League team to New York City. Shea tried first to obtain an existing franchise. He could not and decided to begin a new expansion league, the Continental League, with former National League president Branch Rickey as the head of it. The threat of a third major league forced Major League Baseball to discuss expansion. Two teams would be added to the National League in 1962: the Mets and the Houston Colt .45s. With New York virtually assured a new team, Shea abandoned the idea of the Continental League.

After both of these attempts failed, Shea persevered and finally achieved his goal when he was able to create a new ball club by expanding the National League. Together with Joan Whitney Payson, a 54-year-old heiress and former shareholder in the New York Giants franchise who voted against the Giants' departure to the West Coast, he created the New York Metropolitan

Baseball Club Inc. With everyone set to bring a new team to New York City, plans for the new ballpark began to unfold.

Architects from around the world started submitting sketches and renderings. In November 1957, Shea announced he wanted a stadium built with a retractable dome. Such a dome would have cost approximately $1.75 million, and the idea was quickly abandoned. Another debate was also raging: what should the new team be called? The Bees, the Burros, the Continentals, the Skyscrapers, the Skyliners, and Payson's favorite, the Meadowlarks, were all suggested. Payson, along with George Herbert Walker Jr., ultimately selected the Metropolitan Baseball Club of New York or "Mets" for short.

On March 25, 1960, budget director Abraham D. Beame, future mayor of New York City, requested $450,000 for architects and designers to prepare their final drawings for the stadium. On April 13, 1960, the final model for the stadium was revealed before Wagner, Shea, and Branch Rickey. Praeger-Kavanaugh-Waterbury was hired as the engineering and architectural firm to design the stadium. On April 28, 1960, the green light was given to contractors P. J. Carlin and Thomas Crimmons to begin construction. On January 18, 1961, Wagner announced that the new Flushing Meadows Municipal Stadium, now budgeted at $16 million, would be ready for the Mets' inaugural season in 1962. City controller Lawrence E. Gerosa responded negatively, "Even if construction started last fall, they would still have to work overtime to finish it in time for the 1962 season." One week later, construction was delayed.

Three months later on March 15, the assembly in Albany vetoed the measure that authorized the city to finance and build the new ballpark. Wagner pleaded before the assembly and won. The lease for the new ballpark was approved on October 6, 1961. Under the terms of the lease, the ball club would pay the city $450,000 in rentals for the first year with it decreasing to $300,000 after seven years. The Mets were allowed to lease the stadium for 30 years with an option for renewal of 10 additional years. Finally, on Saturday, October 28, 1961, Wagner along with Robert Moses and New York City Parks Department president Newbold Morris attended the official groundbreaking ceremony. The ceremonial shovels scooped up the rich black soil to the accompaniment of music by the Department of Sanitation Band while the Police Athletic League baton twirlers entertained the crowd. Opera star Elaine Malbin sang "The Star-Spangled Banner," which was quickly followed by a short speech by Moses. "I am limp with the enthusiasm of victory. Unlike the Coliseum in Rome, the new edifice of Emperor Shea will have provisions for expansion of a future cover. Joy has returned to our own favored Flushing Meadow, the sun shines, bands play, children shout as another Casey, Casey Stengel, armed with fractured English comes to bat."

The 1962 baseball season was the Mets' inaugural year. While waiting for Flushing Meadows Municipal Stadium to be completed, the Mets played at the Polo Grounds in Harlem. Fans turned out by the tens of thousands to see the lovable losers at the decrepit old ballpark, the former home of the Giants. They would end their first season in last place. The brand-new ball club, however, was a sight to see. The Mets wore blue, orange, and white, the official colors of New York City. Blue representing the Dodgers and orange representing the Giants were especially symbolic of the return of National League baseball to New York. The Mets logo also depicted a New York City skyline, and each building had a special meaning. At left is a church spire symbolizing Brooklyn, the "borough of churches." The second building from the left is the

Williamsburg Savings Bank, the tallest building in Brooklyn. Next are the Woolworth Building, the Empire State Building, and finally, the United Nations Building. The bridge dominating the background symbolizes that the Mets represent all five boroughs.

Construction was further delayed because of loose girders and broken beams that needed to be repaired, and the opening was moved to April 1964. During its construction, many names were suggested for the new ballpark. Queens Stadium was proposed in late 1962 to identify the ballpark with the borough in which it was built. The name was turned down, and Flushing Meadows Municipal Stadium remained as the official title. It was not until October 30, 1962, that the name William A. Shea Municipal Stadium was considered for the ballpark. It was council vice chairman Erick J. Treulich of Richmond Hill, Queens, who told the city that the name Shea Stadium would be "a way of thanking a man who has worked tirelessly on behalf of the city's thousands of loyal baseball fans." He was backed by city councilmen Edward Sadowsky of Flushing and Thomas Cuite of Brooklyn. On January 15, 1963, the city council voted 20 to 2 to officially name the new home of the New York Mets William A. Shea Municipal Stadium.

As the construction progressed, the cost of the stadium was rising faster than the ballpark itself. An extra $1.7 million was needed, causing the grand total to become $26 million.

Meanwhile at the Polo Grounds, the lovable losers were keeping the public entertained with their on-field antics. The team's first celebrity, "Marvelous" Marv Throneberry, was the center of all attention. In one game in 1963, Throneberry came up to pinch hit. He slapped what could have turned into a triple but was called out at second because he failed to touch the base. When Casey Stengel charged out to argue the call, the umpires told him, "Casey, don't feel bad, but he also missed first."

By March 1964, Shea Stadium was near completion and the city was gearing up for the new ballpark and the 1964 world's fair. The construction of Shea Stadium drew positive and negative criticism from just about every politician, architect, union organization, engineering firm, newspaper, and news agency in New York State. In Jimmy Breslin's immortal book *Can't Anybody Here Play This Game?*, he wrote, "Crawling over the steel beams on this day is the flower of New York's construction trades, a group of 483 tin hatted workers . . . and then it hits you. Now you realize, for the first time what this is all about. . . . They are building a brand new stadium for Marvin Throneberry." When asked if he had seen the new stadium yet, Stengel simply replied in his own special way, "Seen it, why I drew up the plans for the place."

Finally, the official dedication ceremony took place on Thursday, April 16, 1964. Around 1,000 people were in attendance, including Moses, Wagner, Stengel, Payson, and, of course, Shea. "Happy days are here again" was spelled out on the scoreboard. The Department of Sanitation Band was on hand once again playing tunes like "Take Me Out to the Ball Game." It was Stengel who stole the show when he got up to speak. "There are 54 rest rooms," he said. "Twenty-Seven are for women, and I know you want to use them now." Shea took to the podium for the official christening of the stadium. With a radiant smile, Shea began his speech. "I have two bottles here. One has water from that grand tributary, the Gowanus Canal in Brooklyn. The Gowanus is part of the legend of the Dodgers, near whose banks was Ebbets Field. Although you couldn't see the Gowanus from Ebbets Field, you certainly could smell it. The other bottle has water taken from the Harlem River at the very foot of the Polo Grounds. Although it is not customary to christen a stadium like a ship, I'm now pouring this water into the ground here to mix with the waters of

the Flushing River below our stadium." And with that, Shea, holding out one champagne bottle in each hand, poured its water contents onto the field letting it mix into the soil.

With the Mets in their new ballpark adjacent to the world's fair, Flushing became a mega attraction for tourists. "[Shea is] a showplace. This will become one of the must see places for all tourists to New York, like the Empire State Building, Radio City or the Statue of Liberty," said Pirates manager Danny Murtaugh after his first visit to Shea Stadium in 1964. More than 90 percent of Shea's seats are located in foul territory, which adds to the open feeling; but that is offset by the five-tiered grandstands that climb precipitously high above the field. This baseball characteristic was something the National Football League's Jets had to deal with for 20 seasons. Originally known as the New York Titans, the team played its home games at the Polo Grounds. It had trouble attracting crowds, and after a 5-9 season in 1962, the team's future was in doubt. It was saved from bankruptcy by Sonny Werblin and Leon Hess, who bought the team from Harry Wismer on March 13, 1964. After Werblin and Hess took over, the team was renamed the New York Jets. The newly revamped club was ready to move into its new home in Flushing Meadows. The team's colors were also changed from blue and gold to kelly green and white, which were the colors of Leon Hess's gasoline stations.

After 29 months of construction, Shea Stadium opened on Friday April 17, 1964, before 48,736 fans. The first pitch of the game was a called strike to Dick Schofield of the Pittsburgh Pirates. The first Met to get a hit in the new stadium was Tim Harkness, who smacked a single in the bottom half of the third. Willie Stargell made the first offensive hit when he slammed a home run in the top of the second. The Mets would go on to lose 4-3.

In their first season at Shea Stadium, the Mets attracted 1,732,597 paying customers, an increase of 700,000 over their 1963 attendance at the Polo Grounds.

Shea was a very visible figure during his career with the team and stadium he helped to create. On every opening day, Shea would present the manager of the Mets with a floral wreath. After his passing on October 2, 1991, his family continued the tradition.

Shea Stadium has been the place for many of baseball's greatest moments. The roar of passing airplanes from nearby LaGuardia Airport is a noise so deafening that players often call time out and step out of the batter's box until the roar subsides. Over the years, other recognizable sounds have been provided by organist Jane Jarvis. In left field are the retired numbers of four legends: No. 37 for Casey Stengel in 1965; No. 14 for Gil Hodges, added in 1973; Tom Seaver's No. 41 in 1988; and No. 42 for Jackie Robinson, retired by Major League Baseball in 1997. And whenever a player hits a home run, that big apple emerges from an upside-down top hat in center field and is accompanied by a small fireworks show. Although Mets fans have longed for a new stadium since the early 1980s, reality, however, is beginning to sink in, and that beautiful field that is so recognizable in baseball lore will soon become nothing more but a sea of parking spaces and black asphalt. Citi Field, constructed right in Shea's parking lot, opens in April 2009.

<div align="right">
Jason D. Antos
Whitestone, New York
</div>

IN THE BEGINNING

Before Shea Stadium and the Mets, the New York Giants played at the Polo Grounds, one of the oldest ballparks in the city. Home to the Giants for over half a century, the ballpark was rebuilt four times. The first Polo Grounds, located in Central Park, was torn down in 1888. The ballpark was relocated to 157th Street and used from 1889 until 1890 before it too was demolished. Finally relocated to West 155th Street and Eighth Avenue at Coogan's Bluff in Harlem, the third Polo Grounds was used by the Giants from 1891 until 1911 when the stadium was destroyed by fire. The fourth and final version lasted from 1911 until its closing in 1963.

From 1913 until 1922, the New York Yankees used the Polo Grounds before moving into the "House that Ruth Built" in the Bronx. The location called Coogan's Bluff is actually a large cliff located north of 155th Street in Manhattan. Giants owner John T. Brush bought the land for the stadium from James J. Coogan. The Polo Grounds literally sat in a valley that descended 175 feet below sea level. Many people looking down from the street above could actually watch games for free.

Many historic moments in baseball took place here at Coogan's Bluff. On August 1, 1945, Mel Ott hit his 500th home run. In 1946, it hosted Game 1 of the Negro League World Series. On October 3, 1951, Bobby Thomson hit his "shot heard 'round the world" to defeat the Brooklyn Dodgers and win the pennant. On September 29, 1954, Willie Mays made his famous catch in center field.

The stadium was deteriorating by the time the Giants moved west. On September 29, 1957, the Giants played their last game at the Polo Grounds. When it was announced that the Mets would be using the ballpark while waiting for Shea Stadium to be built, maintenance and restoration work ceased and the Polo Grounds began to fall apart. At the end of the final game played on September 18, 1963, the several thousand fans on hand stormed the field, literally chasing the Mets to their clubhouse located in the outfield. The scoreboard, sod, and even the seats fell victim to vandalism. Demolition of the Polo Grounds began on April 10, 1964, one week before the New York Mets' first game at Shea Stadium.

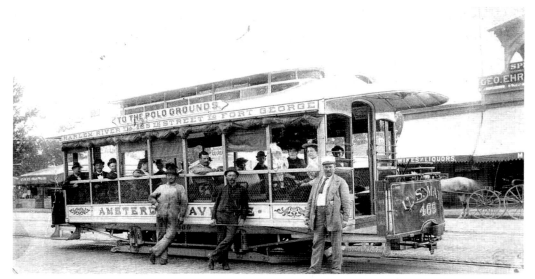

Before the No. 7 train carried fans to Willets Point Boulevard to see the Amazin's play at Shea Stadium, the New York Giants at the Polo Grounds were one of the biggest sports venues in New York City. The trolley shown here is taking passengers to the Polo Grounds up the Harlem River via 195th Street. The conductor and his passengers pose in front of the Polo Grounds' special trolley in this photograph from the early 1900s. (Author's collection.)

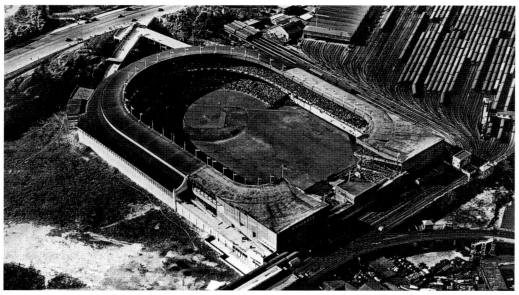

The Polo Grounds opened on June 28, 1911. This was the fourth version of the stadium to be constructed after the previous ballpark was destroyed by fire. The unmistakable horseshoe design caused the center field wall to be almost 500 feet in length. Luke Easter, Joe Adcock, Lou Brock, and Hank Aaron are the only four players to ever hit a homer over the center field wall. (Author's collection.)

IN THE BEGINNING

The Polo Grounds (upper) and Yankee Stadium (lower) are pictured here in this aerial photograph. The short distance between the two ballparks is astounding as the Harlem River separates Manhattan from the Bronx, placing the National League on one side and the American League on the other. (Author's collection.)

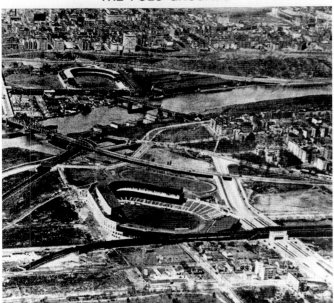

YANKEE STADIUM

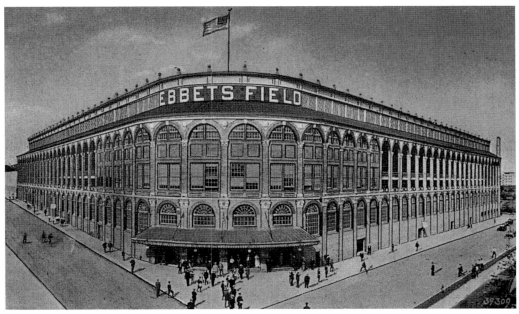

The most fabled ballpark in baseball history was the home of the Brooklyn Dodgers located in the Flatbush section of Brooklyn. Ebbets Field was designed by Clarence Randall van Buskirk and built by Brooklyn Dodgers owner Charlie Ebbets in 1913 at the cost of $750,000. Castle Brothers Inc. constructed the ballpark in just nine months. A stunning 80-foot circular rotunda, whose interior was made of Italian marble, greeted fans as they entered the stadium. (Author's collection.)

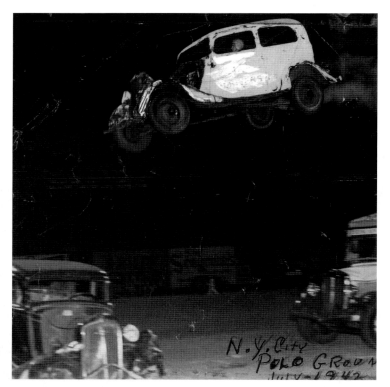

The home of the New York Giants was used for many events other than baseball. The Polo Grounds was the site of many famous boxing matches, notably the legendary 1923 heavyweight championship bout between Jack Dempsey and Argentine Luis Firpo. Shown here is a race car stunt show at the ballpark on July 11, 1942. (Author's collection.)

Ebbets Field had its date with the wrecking ball on February 23, 1960. Here the entire outfield wall has been destroyed as well as the scoreboard and grandstands, which once sat 32,000 fans. All that is left is a ghostly shell that includes the famous rotunda. The very same wrecking ball was used four years later to destroy the Polo Grounds. (Author's collection.)

IN THE BEGINNING

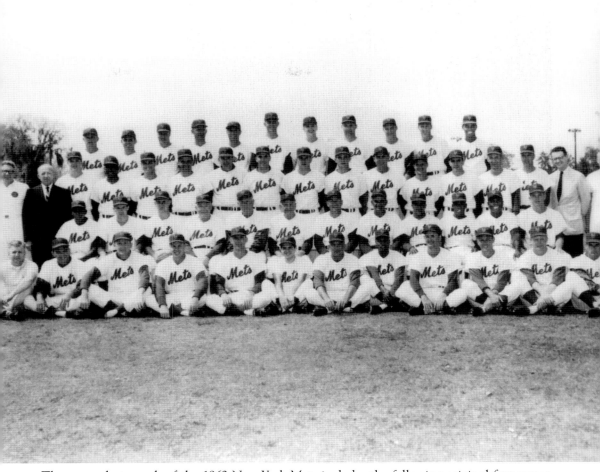

The team photograph of the 1962 New York Mets includes the following original first-season players: Clarence "Choo Choo" Coleman, "Marvelous" Marv Throneberry, Gil Hodges, Roger Craig, Jay Hook, Don Zimmer, Frank Thomas, Felix Mantilla, Richie Ashburn, Al Jackson, Joe Pignatano, Jim Hickman, Elio Chacon, Vinegar Bend Mizell, Chris Cannizzaro, Bob Miller, Joe Christopher, Harry Chiti, Rod Kanehl, Galen Cisco, Gus Bell, Charlie Neal, Ken MacKenzie, Gene Woodling, Clem Labine, Ed Bouchee, Craig Anderson, Hobie Landrith, Cliff Cook, Joe Ginsberg, Herb Moford, Bob Morehead, Sherman Jones, Ray Daviault, Bob Miller, Willard Hunter, Sammy Taylor, Sammy Drake, Rick Herrscher, Larry Foss, John DeMerit, Dave Hillman, Jim Marshall, Bobby Gene Smith, and Ed Kranepool. (Courtesy of the New York Mets.)

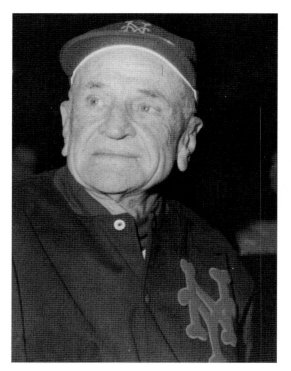

"The Old Professor," Charles Dillon "Casey" Stengel, began his professional baseball career in 1912 with the Brooklyn Dodgers. In 1962, Stengel became the first manager of the New York Mets. He finished the team's inaugural year in 10th place with 60.5 games out of first. "When I go back in my mind to our play in 1962, I just wonder how we ever got to win 40 games." Still active at the age of 72, Stengel became the perfect father figure for the lovable losers. He retired in 1965 after breaking his hip at the age of 75. (Author's collection.)

Nicknamed "the Miracle Worker," Gil Hodges was 19 years old when he broke into the major leagues with the Brooklyn Dodgers in 1943. He was traded in 1962 to the Mets. During the team's inaugural season, Hodges batted .252 and hit nine homers and had 32 base hits. The following year would be his last as a player. In 1968, he became the team's manager. Hodges passed away in 1972. Yankee legend and hall of famer Yogi Berra would become the new Mets manager from 1972 to 1975. (Courtesy of Corbis/Bettmann.)

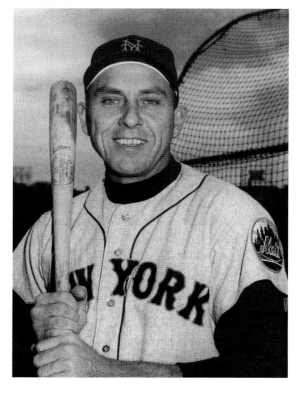

Duke Snider, "the Duke of Flatbush," was traded to the New York Mets in 1963 from the Dodgers. Snider had been with the team since its Brooklyn days starting in 1947. Snider spent one season with the Mets in what would become the twilight of his career. After the season, he requested to be traded to a more competitive team. Snider was traded to the San Francisco Giants and retired at the end of the 1964 season. (Author's collection.)

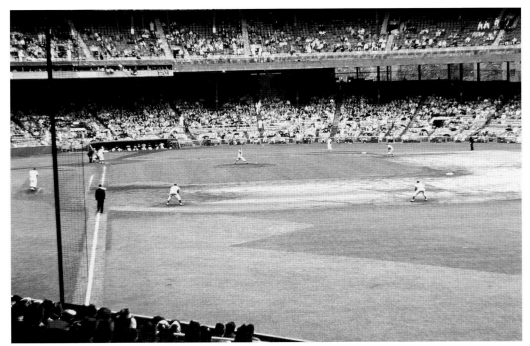

The New York Mets' inaugural home game at the Polo Grounds took place on Friday, April 13, 1962. The starting pitcher for the game was Sherman Jones. In the team's first season a total of 922,530 fans, mainly former Brooklyn Dodgers and Giants fans, turned out to witness the return of the National League to New York City. (Author's collection.)

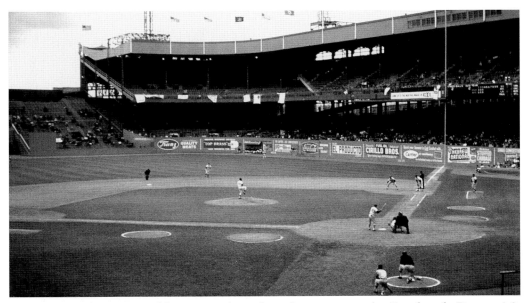

The New York Mets would go on to lose their first game to the Pittsburgh Pirates 4-3. (Author's collection.)

IN THE BEGINNING

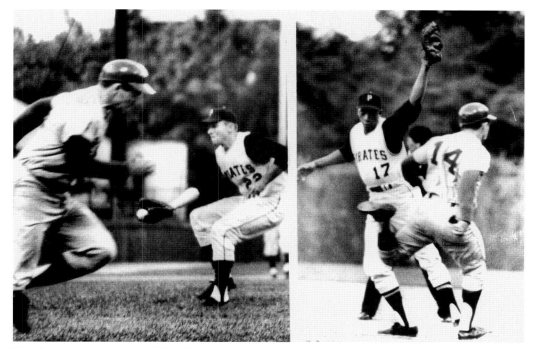

The first several seasons of franchise existence were tough. From 1962 until 1968, the New York Mets never made it beyond eighth place. One of the early Mets, Ron Swoboda, is shown here racing for first as Pittsburgh Pirate pitcher Joe Gibson fields his grounder in the first panel. The ball is tossed to future Met Donn Clendenon in the second panel for the out. (Courtesy of United Press International.)

Mets center fielder Rod Kanehl reaches for Cookie Roja's drive but the ball eludes him. Moments like these were typical in the Mets' first troubling seasons. (Courtesy of AP/Wide World Photos.)

Marv Throneberry, first baseman for the New York Mets, poses at the Polo Grounds in 1962. Throneberry became the first official star of the Mets. The fans nicknamed him "Marvelous" Marv because of his crazy on-field mishaps. (Courtesy of AP/Wide World Photos.)

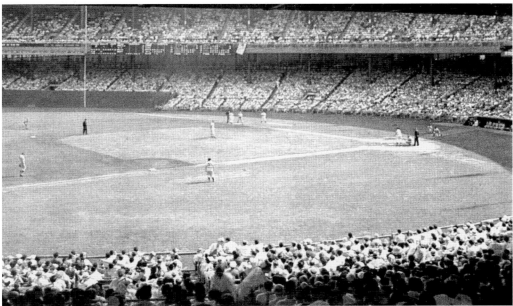

In their two seasons at the Polo Grounds and despite having the worst record in baseball, the Mets attracted huge crowds. From 1962 through 1963, approximately 1,254,000 people came to Coogan's Bluff to see the lovable losers play. (Author's collection.)

IN THE BEGINNING

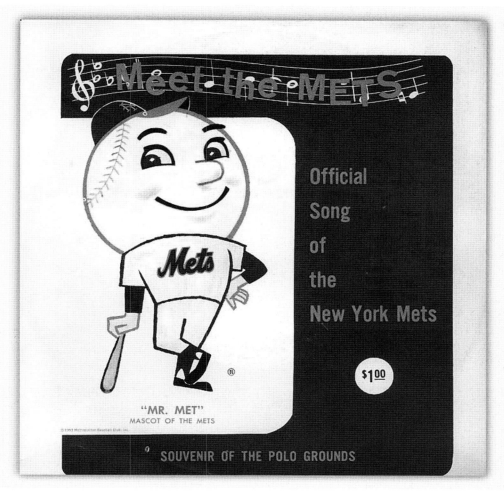

In November 1961, Ruth Roberts and Bill Katz submitted the lyrics of "Meet the Mets" to the Metropolitan Baseball Club. On March 1, 1963, the song was recorded by Glenn Osser and his orchestra and chorus. The song was introduced to the public for the first time on Saturday, March 9, 1963, and quickly became the official song of the New York Mets. This 45 rpm, featuring Mets mascot Mr. Met on the cover, was given to fans at the Polo Grounds as a promotional item. For extra copies fans had to pay $1. (Author's collection.)

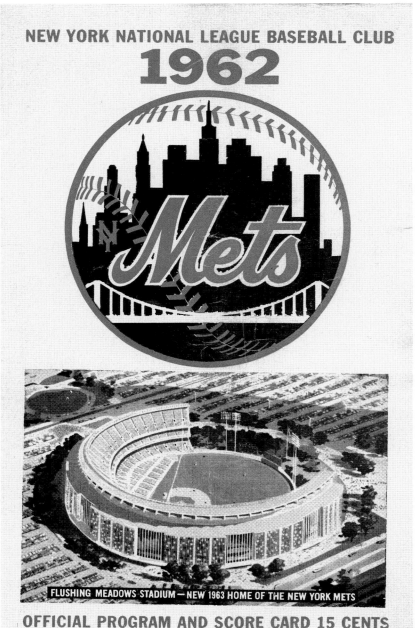

NEW YORK NATIONAL LEAGUE BASEBALL CLUB
1962

FLUSHING MEADOWS STADIUM—NEW 1963 HOME OF THE NEW YORK METS

OFFICIAL PROGRAM AND SCORE CARD 15 CENTS

This was the first program for the 1962 New York Mets. At the bottom is an artist's rendition of the team's new home in Flushing Meadows, Queens. The caption below the photograph describes this early image of the ballpark as "Flushing Meadows Stadium—New 1963 Home of the New York Mets." The name and year would go on to change. The ballpark's name was changed to honor the most influential figure in returning National League baseball to New York City, William A. Shea. The construction of Shea Stadium delayed the opening until 1964. (Author's collection.)

IN THE BEGINNING

This is the Polo Grounds on the last day of the 1963 season. The exterior is visibly deteriorating. The famous wooden ramp shown along the side allowed fans to enter and exit the ballpark. (Author's collection.)

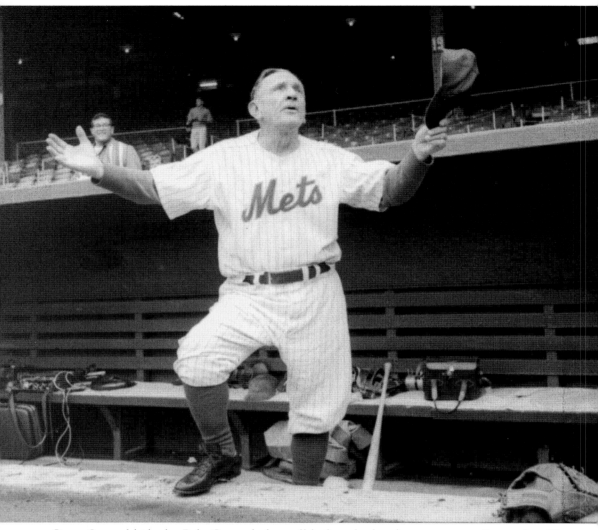

Casey Stengel bids the Polo Grounds farewell before the last home game on September 18, 1963, against the Philadelphia Phillies. The Mets, in true fashion, lost 5-1. After the game, broadcasters Ralph Kiner, Bob Murphy, and Lindsey Nelson gave a history of the stadium before a live television audience. The date for the wrecking ball was set for April 10, 1964. (Courtesy of AP/Wide World Photos.)

IN THE BEGINNING

A NEW STADIUM IS BORN

On October 28, 1961, ground was broken for the new stadium in Flushing Meadows. Mayor Robert Wagner, Robert Moses, and parks department president Newbold Morris, along with other officials from the New York City Parks Department, attended the ceremony.

The architectural firm of Praeger-Kavanaugh-Waterbury designed the stadium to be the first all-purpose facility capable of hosting both baseball and football games, seating 55,300 for baseball and 60,000 for the New York Jets football team. Also Shea Stadium's coliseum-like structure could be supported without the use of beams in between each level of the grandstands. This would be the first time that fans could watch a ball game without an interrupted view of the field. The construction companies of P. J. Carlin and Thomas Crimmons began work quickly although financial matters would slow down the project by almost a year.

According to the 1964 world's fair guidebook, "Long after the Fair is gone, Shea Stadium will remain as the ultimate in modern sports arenas."

At the dedication ceremony on April 16, 1964, Mets manager Casey Stengel stole the show when he stood at the podium on the pitcher's mound and before an audience of 1,000 announced, "I know every youngster would love to be able to play in this beautiful park. People don't need binoculars to see the field. You can have your health for many years by following my Mets. Just see the escalators and elevators they put in for the old folks."

Shea Stadium opened on April 17, 1964. The New York Mets played the Pittsburgh Pirates before 48,736 fans. Jack Fisher started the first game at the new ballpark with a called strike to Pittsburgh's leadoff batter Dick Schofield. In the second inning, Willie Stargell introduced the ballpark to its first home run, when he belted the 12th of his 475 career home runs. Fisher pitched well for seven innings but was relieved by Ed Bauta. The Mets lost in the ninth inning when Bill Mazeroski drove in the winning run for a 4-3 Pirates victory.

In December 1964, joint contractors P. J. Carlin and Thomas Crimmons were awarded first prize by the Building Awards Committee of the Queens Chamber of Commerce, citing Shea Stadium as "the most beautiful ballpark ever built."

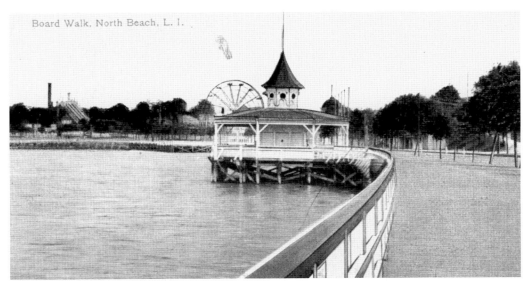

Board Walk. North Beach, L. I.

Before people found entertainment at the 1964–1965 world's fair and before fans flocked to Shea Stadium for excitement, there were the bathing pavilions and amusement park at North Beach. Located just several hundred feet from Shea Stadium, it was created by brewery owner George Ehret and piano manufacturer William Steinway. North Beach opened on June 19, 1886. Under the dome stood a Kremer's carousel featuring wooden animals carved by Mr. Kremer himself. In the background is the grand Ferris wheel. This postcard view is from 1892. (Author's collection.)

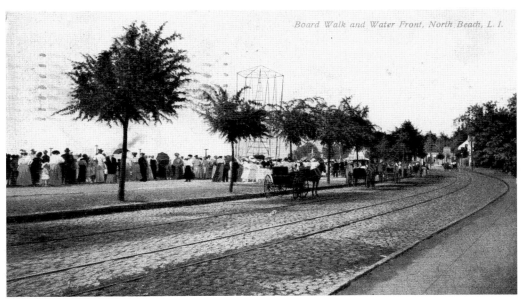

Board Walk and Water Front, North Beach, L. I.

A large crowd gathers on the boardwalk at North Beach overlooking what was then called Bowery Bay. Horse and buggies can be seen lined up alongside the trolley tacks. The boardwalk was a very popular spot for people bathing in Flushing Bay or just taking an afternoon stroll. This postcard image is from the summer of 1900. (Author's collection.)

A NEW STADIUM IS BORN

No. 22. Public School No. 15, Junction Avenue, Corona, N. Y.
PUB. BY C. BERNHARDT, JR. CORONA

This is where I am going next Monday. At least I hope I am. Irene.

In 1905, this small wooden schoolhouse was located south of Northern Boulevard, toward Roosevelt Avenue about 100 yards from where Shea Stadium is located today. Northern Boulevard was formerly known as Jackson Avenue and than as Broadway. (Author's collection.)

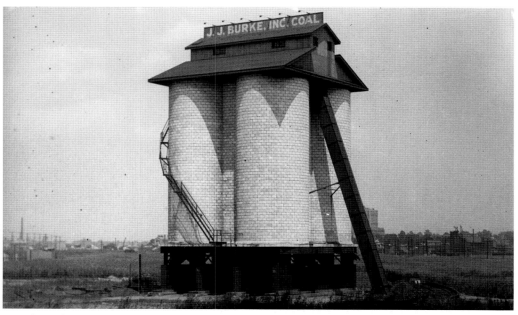

Standing alone among the ash fields is the silo for the J. J. Burke Incorporated Coal company at Roosevelt Avenue and Willets Point Boulevard. The open land in the background would soon become the infamous junkyards. This photograph is from 1929. (Courtesy of the Queens Borough Public Library, Long Island Division, Illustrations-Flushing Meadows.)

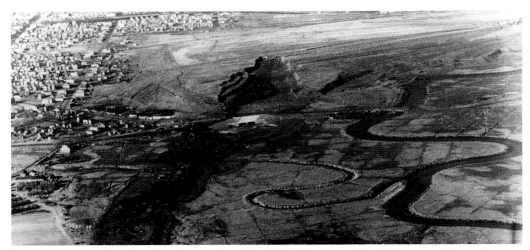

The Flushing River snakes its way through the ash pits adjacent to Flushing Meadows. In the background a huge chasm of ash can be seen. In the upper left-hand corner, new housing developments slowly make their way over the huge vacant area of swampland and marshes. Just below the chasm is Strong's Causeway, which was a bridged passage over Flushing Creek and later absorbed into the Long Island Expressway. Shea Stadium will appear 25 years later in the lower left-hand corner. This aerial photograph is from May 1936. (Courtesy of the Queens Borough Public Library, Long Island Division, Illustrations-Flushing Meadows.)

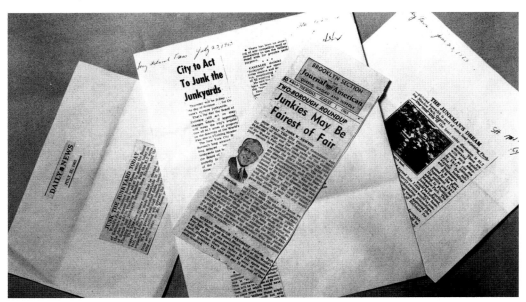

An array of articles from various local newspapers shows the negative reviews over the existence of the junkyards. The city planning committee and the board of estimate were prepared to spend $4.8 million to remove the junkyards that cover almost 82 acres. But the owners put up a very successful battle. As of this date the yards still remain. (Courtesy of the Queens Borough Public Library, Long Island Division, Illustrations-Flushing Meadows.)

A NEW STADIUM IS BORN

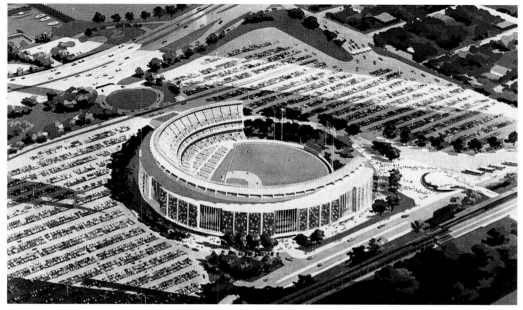

This is an artist's rendition of Shea Stadium. This drawing is very close to how the final physical structure would appear. (Courtesy of Tippetts-Abbett-McCarthy-Straton Engineers and Architects.)

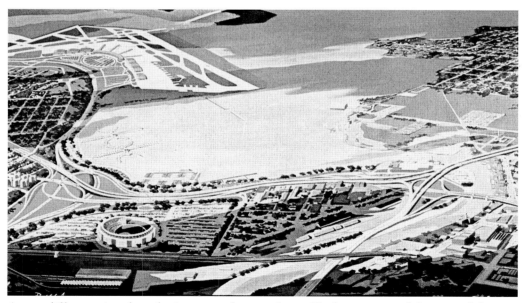

A very different view than the image on the top of page 28, this is an aerial drawing of the area surrounding Shea Stadium, located in the bottom left-hand corner. The Whitestone Expressway, Grand Central Parkway, and Northern Boulevard can be seen next to the ballpark. North of the stadium is LaGuardia Airport. (Courtesy of Tippetts-Abbett-McCarthy-Straton Engineers and Architects.)

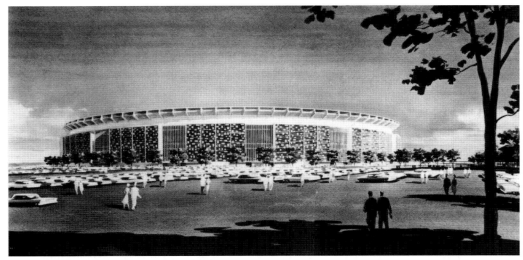

This artist's rendition is of the exterior of what was then called Flushing Meadows Municipal Stadium in 1961. The small aluminum multicolored tiles were a major aspect of the stadium. The drawing also shows the parking lot and its convenient distance from the stadium. The support cables for these squares still remain to this day. (Courtesy of the Milstein Division of United States History, Local History and Genealogy; the New York Public Library; Astor, Lenox and Tilden Foundations.)

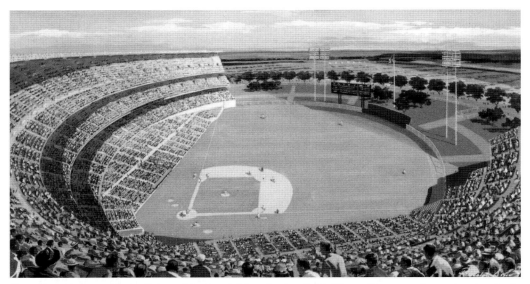

Seen here is a second rendition, this time of the playing field. The coliseum-style seating was built almost exactly as shown here. The only difference is the location of the scoreboard, which itself appears to be of an old-fashioned style that involves handlers putting the line score numbers in place by hand. The concept of openness with all attention directed at the field was essential in the design of Shea Stadium. (Courtesy of the Milstein Division of United States History, Local History and Genealogy; the New York Public Library; Astor, Lenox and Tilden Foundations.)

A NEW STADIUM IS BORN

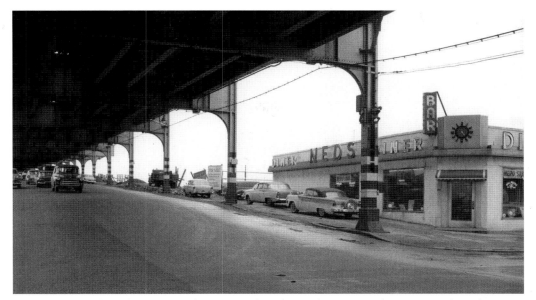

Before Shea Stadium there was Ned's Diner and Bar located on Roosevelt Avenue and 126th Street. This structure, located across the street from the ash lot, was one of the only businesses in the area aside from the junkyards, which date back to the early 1930s. (Courtesy of Queenspix.com.)

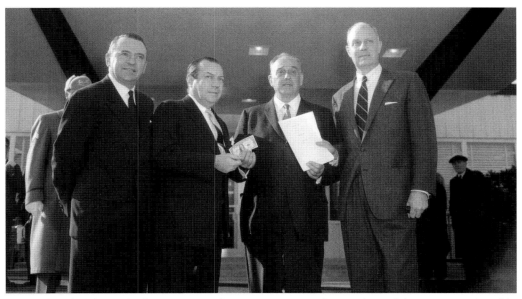

Former head of the parks department Robert Moses was made president of the 1964–1965 world's fair. This would be the second fair to be hosted at Flushing Meadows. Here at the groundbreaking ceremony in 1961, New York City mayor Robert Wagner hands Moses $1 and the lease for the usage of Flushing Meadows for the fair. Standing to the right of Moses, handing him the lease, is parks department president Newbold Morris. (Courtesy of United Press International.)

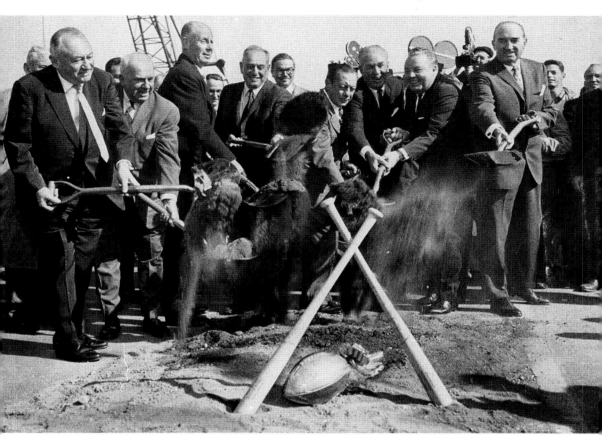

The groundbreaking ceremony for Shea Stadium took place on October 28, 1961. Shown here with their ceremonial shovels pouring dirt over two Mets bats and a Jets football are, from left to right, George Weiss, president of the New York Mets; Warren Giles, president of the National League; parks department commissioner Newbold Morris; Robert Moses, president of the 1964–1965 world's fair; Mayor Robert Wagner; Donald Grant of Cederhurst, coowner of the Mets; Harry Wismer, president of the Titans; and Borough Pres. John T. Clancey. (Photograph by Phil Greitzer; courtesy of the New York Daily News.)

A NEW STADIUM IS BORN

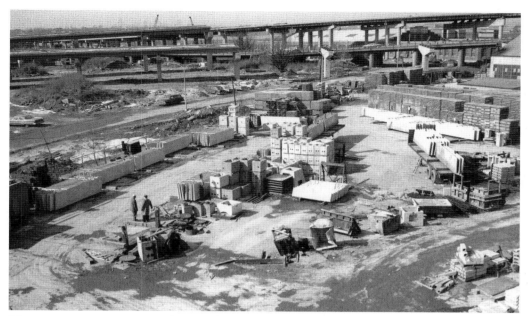

The construction companies of P. J. Carlin and Thomas Crimmons begin to lay out their materials to start construction on Shea Stadium here in 1961. However, work would not begin until May 13, 1962. (Courtesy of Queenspix.com.)

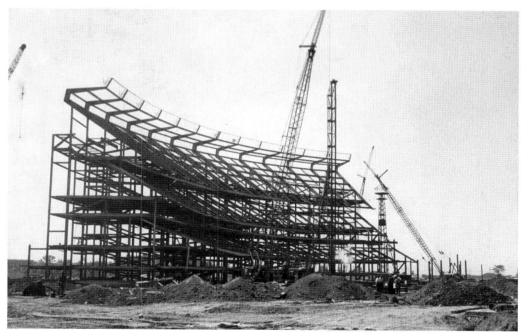

The skeleton of Shea Stadium begins to take shape as cranes assemble the grandstand along the right field line. This photograph was taken on July 13, 1962. (Photograph by Tom Gallagher; courtesy of the New York Daily News.)

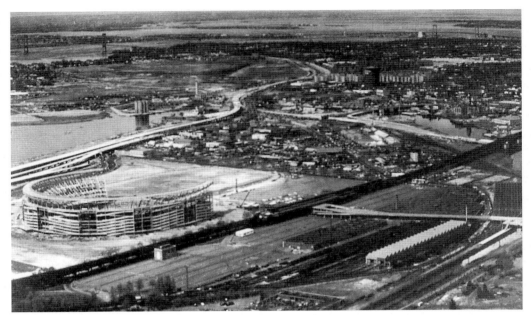

The ballpark, located on the bottom left, is beginning to take form. The seats and field have not yet been installed. The ballpark is flanked by the Interborough Rapid Transit Company (IRT) No. 7 train on the south side and the Whitestone Expressway on the north side. Adjacent to Shea Stadium are the junkyards, also known as the "Iron Triangle." (Author's collection.)

Workers assemble the tracks that will allow the field-level seats to be reconfigured for New York Jets football games. (Courtesy of the New York City Parks photograph archive.)

A NEW STADIUM IS BORN

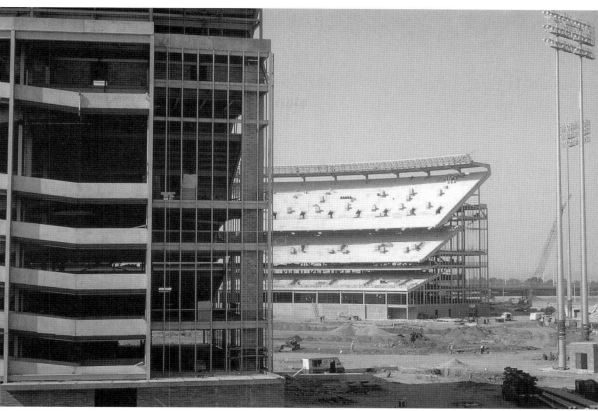

Shea Stadium is almost near completion in this photograph taken in the summer of 1963. The field is still just a series of dirt mounds but will soon begin to take shape. The ramps and the grandstands still need to be filled in with their respective components. In the outfield by the warning track is a small truck delivering lunch to the construction crews. The field dimensions for baseball would be as follows: left and right field, 338 feet; medium-left and right-center field, 358 feet; right and left-center field, 371 feet; left and right-center field (deep), 396 feet; and center field, 410 feet. (Author's collection.)

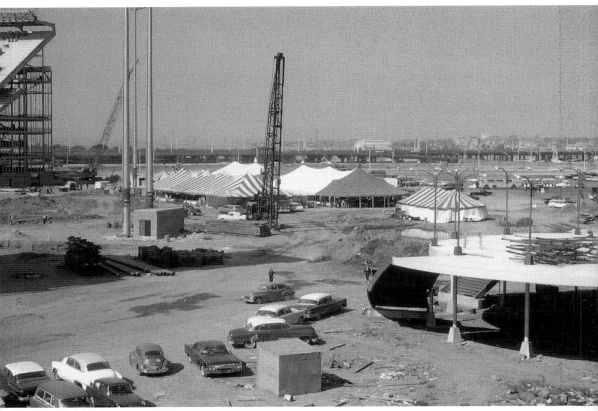

Construction crews work around the clock to complete the already delayed Shea Stadium for its April 1964 opening in this photograph from the summer of 1963. In the background are the workers' tents. To the right is the building of the ramp leading to and from the No. 7 train platform. At left is the nearly completed stadium. The grandstands are in place; however, the seats have not yet been installed. Notice the period cars below. (Author's collection.)

A NEW STADIUM IS BORN

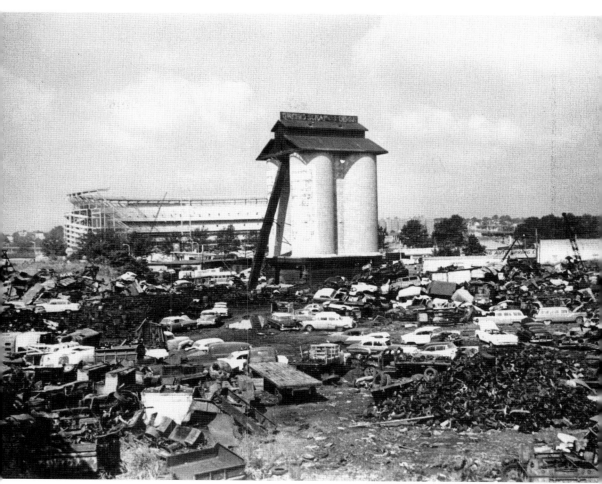

The coal mill is now surrounded by the massive junk and wrecking yards known as the "Iron Triangle." In the background, Shea Stadium is nearing completion in this photograph taken in early 1964. This view is from Roosevelt Avenue looking west adjacent to Willets Point Boulevard. (Courtesy of the Queens Borough Public Library, Long Island Division, Illustrations-Flushing Meadows.)

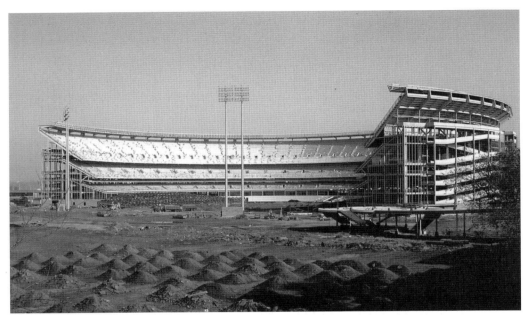

A view from the soon-to-be parking lot is nothing more than mounds of dirt. Shea Stadium is coming along rapidly as the seats are now being mounted into place. The lower right field level is also being built. (Courtesy of Bill Cotter.)

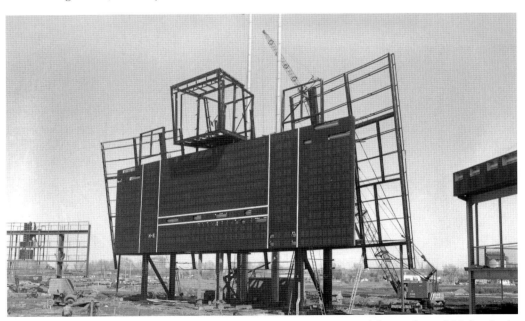

The new scoreboard, the largest in the major leagues measuring 175 feet wide and 80 feet high, had the first electronic display in baseball history. The square box on the top center housed a movie screen. Whenever a Met would come up to bat the rear projector would display the face of the player on the screen. (Courtesy of Queenspix.com.)

A NEW STADIUM IS BORN

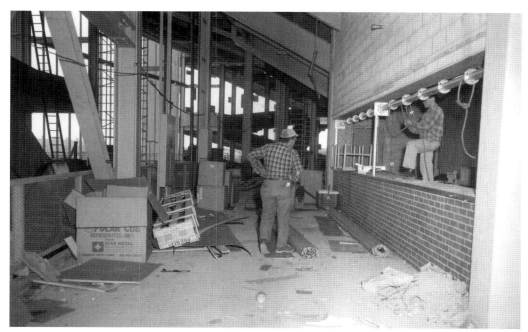

This image of the interior of Shea Stadium shows two construction workers installing one of the numerous concession stands. In the background are the escalators. Boxes labeled "Refrigerated Unit" are strewn about the walkway. (Courtesy of Thomas Crimmons Contractors.)

The ballpark is almost ready. This rare postcard offers a view of Shea Stadium before the installation of the small multicolored aluminum squares that decorated the entire exterior of the ballpark. (Author's collection.)

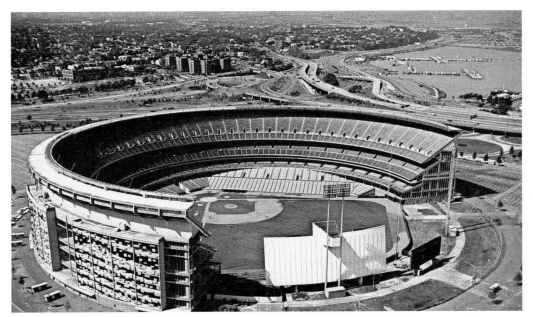

This aerial view shows the nearly completed Shea Stadium several weeks before its grand opening. The decorative squares have now been added. (Author's collection.)

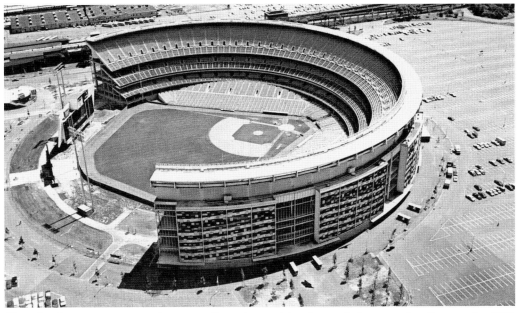

Shea Stadium is now complete as well as the parking lot and the steps leading to the IRT. The new stadium's address would become 123-01 Roosevelt Avenue, Flushing, New York. (Author's collection.)

A NEW STADIUM IS BORN

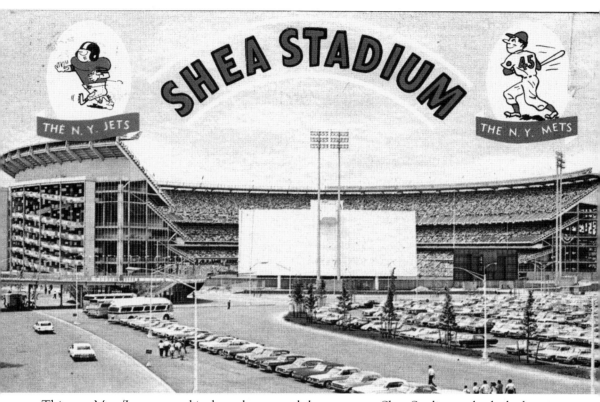

This rare Mets/Jets postcard is the only postcard that promotes Shea Stadium as both the home of baseball and football. The image in the background shows a packed Shea Stadium around the time of opening day. (Author's collection.)

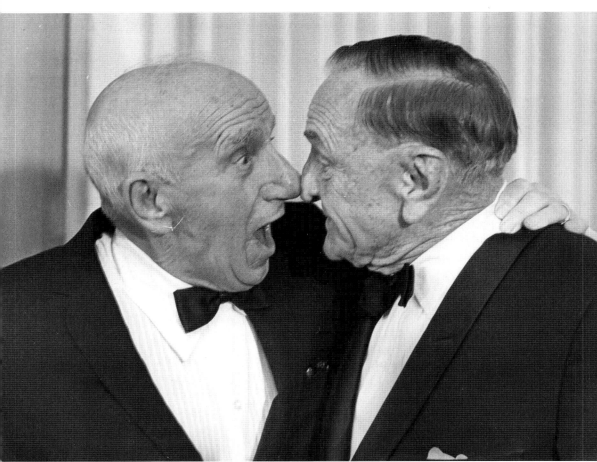

Casey Stengel (right) and Jimmy Durante joke around during a dinner for the Catholic Youth Organization (CYO). Durante received the CYO's Club of Champions Gold Medal while Stengel received the organization's John V. Mara Memorial Sportsman of the Year Award. Stengel was best known for his unique take on the English language dubbed by the media as "Stengelese." (Courtesy of United Press International.)

A NEW STADIUM IS BORN

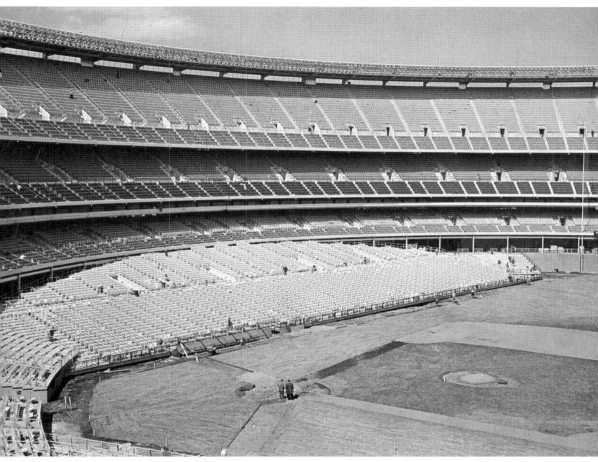

Shea Stadium, just several days from its dedication, featured multicolored seating levels. In the 1960s, the original colors were different from the shades of today. Field-level seating was painted yellow. The lodge was orange, the mezzanine blue, and the upper deck was painted green. Darker corresponding shades of yellow, orange, blue, and green were painted for each level's box section. (Courtesy of Praeger-Kavanaugh-Waterbury.)

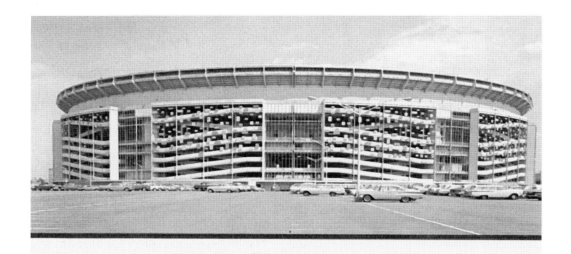

Dedication

WILLIAM A. SHEA MUNICIPAL STADIUM

This is the official program to the dedication ceremony at Shea Stadium on Thursday, April 16, 1964. Only 1,000 people turned out for the ceremony where Casey Stengel, Robert Moses, and William A. Shea all spoke positively on the country's most modern sports arena. (Author's collection.)

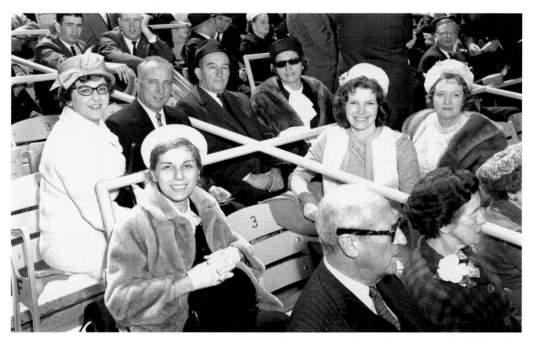

This is a close-up of well-dressed spectators visiting in the stands during the Shea Stadium dedication. Everyone is smiling and so nicely dressed. (Courtesy of the New York City Parks photograph archive/Ben Cohen.)

A NEW STADIUM IS BORN

In this rare photograph from April 16, 1964, Mayor Robert Wagner and William A. Shea celebrate the dedication of Shea Stadium. Shea, on the right, presents Wagner with a gift: a stainless steel cigarette box featuring an engraved layout of the ballpark. (Courtesy of the New York City Parks photograph archive/Ben Cohen.)

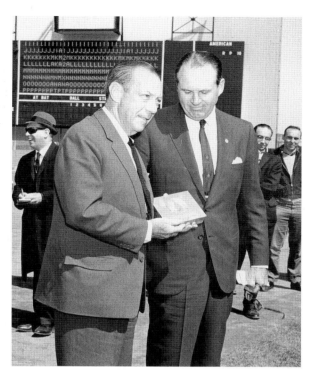

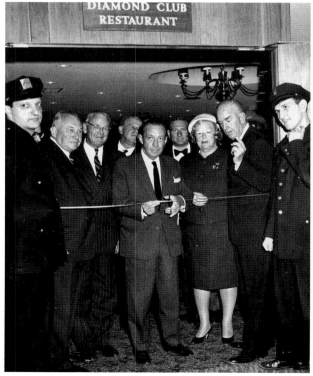

On April 16, 1964, Wagner and New York Mets owner Joan Whitney Payson cut the ceremonial ribbon before hosting the dedication dinner at the New York Mets Diamond Club at Shea Stadium. (Courtesy of the New York City Parks photograph archive/Ben Cohen.)

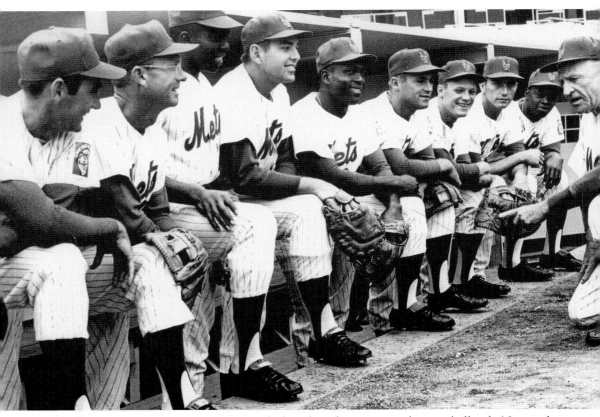

Casey Stengel talks with his teammates before their first game in the new ballpark. Notice the 1964–1965 world's fair patches on each player's left arm. (Author's collection.)

A NEW STADIUM IS BORN

The official opening day program shows the completed stadium, the world's fair, and a Mets player in action looking upward with pride as he hits a home run. Unfortunately for the Mets in 1964, moments like these would be very rare. (Author's collection.)

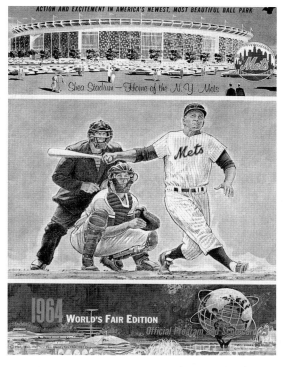

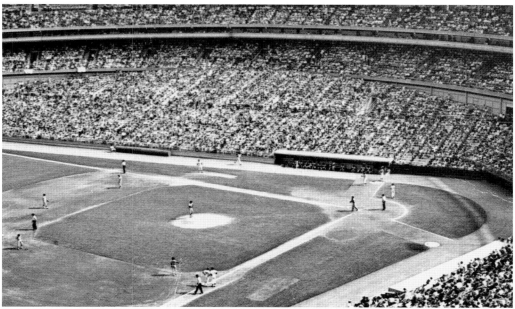

On opening day at Shea Stadium, on Friday, April 17, 1964, 48,763 fans turned out for the Mets' inaugural game at Flushing Meadows. They would lose to the Pittsburgh Pirates 4-3. (Photograph by John Quigley; courtesy of the Queens Borough Public Library, Long Island Division, Postcard Collection.)

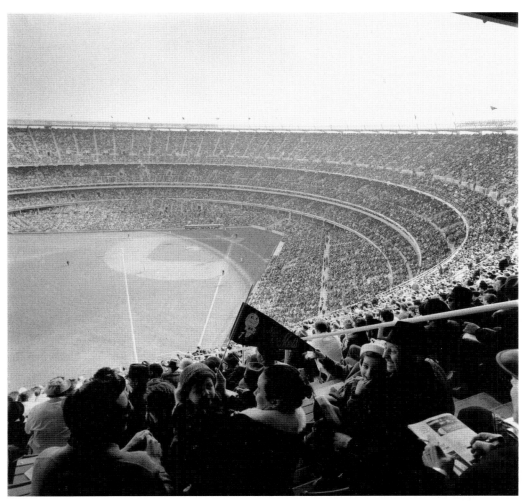

There is absolute joy on the faces of the fans as tens of thousands come out to Shea Stadium to watch the New York Mets play their first game in their new ballpark. (Courtesy of AP/Wide World Photos.)

A NEW STADIUM IS BORN

A ticket stub to the second game ever played at Shea Stadium is seen here. The Mets played the Pittsburgh Pirates and lost their fourth straight game by a score of 9-5. The cost of season tickets for the field level was only $215. (Author's collection.)

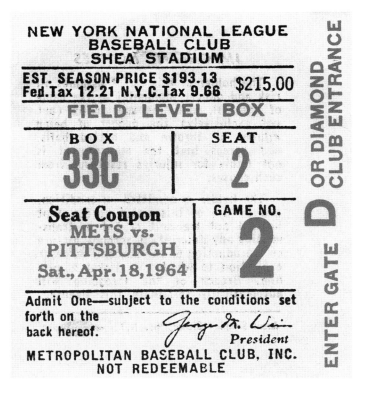

NEW YORK NATIONAL LEAGUE
BASEBALL CLUB
SHEA STADIUM

EST. SEASON PRICE $193.13
Fed.Tax 12.21 N.Y.C.Tax 9.66 $215.00

FIELD LEVEL BOX

BOX
33C

SEAT
2

Seat Coupon
METS vs.
PITTSBURGH
Sat., Apr. 18, 1964

GAME NO.
2

Admit One—subject to the conditions set forth on the back hereof.

George M. Weiss
President

METROPOLITAN BASEBALL CLUB, INC.
NOT REDEEMABLE

OR DIAMOND
CLUB ENTRANCE

D

ENTER GATE

Shea Stadium was packed with people its first season with fans who would visit the world's fair right across the street after the game. (Author's collection.)

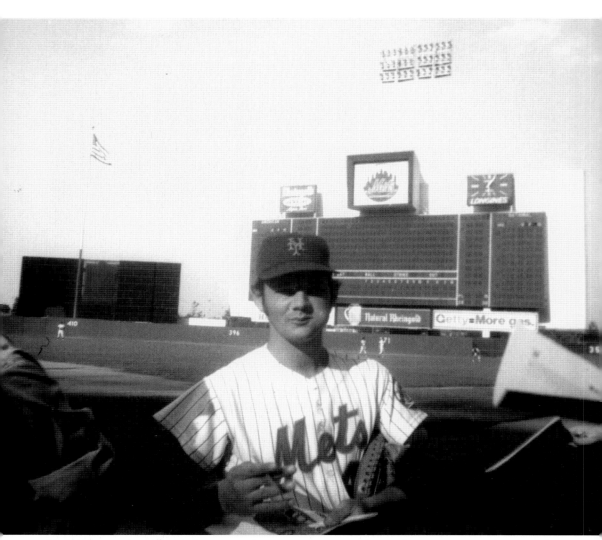

Early Mets catcher Ron Hodges is seen here signing autographs. Hodges was a great admirer of the team from its beginning and ended up playing for the Mets from 1973 until 1984. (Photograph by Diane Gambino; courtesy of the Queens Borough Public Library, Long Island Division, Portraits Collection.)

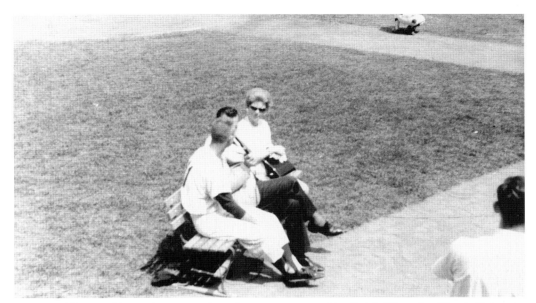

Roy McMillan and his wife are seen here being interviewed by Ralph Kiner for *Kiner's Korner* in this photograph from the spring of 1964. McMillan came to the Mets in 1964 from the Milwaukee Braves. In his three seasons as the team's shortstop McMillan had 255 hits and 79 RBIs in 1,127 at bats. In 1975, he replaced Yogi Berra as manager. (Courtesy of the McMillan Estate.)

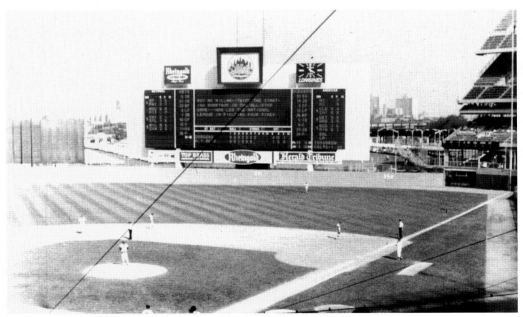

The scoreboard displays McMillan's name. It reads, "Roy McMillan—twice the starting shortstop in the All-Star Game—has led the National League in fielding four times." According to the scoreboard, the Mets are also losing to the Los Angeles Dodgers 4-1 in the bottom of the seventh inning. (Courtesy of the McMillan Estate.)

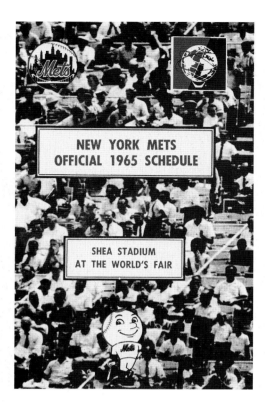

The official New York Mets 1965 schedule reads, "Shea Stadium at the World's Fair." Above are the Mets and world's fair logos. Below is a smiling Mr. Met. (Author's collection.)

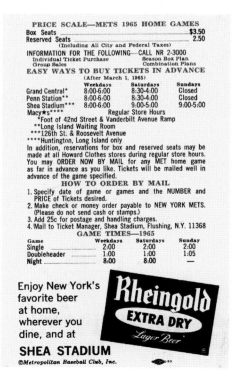

PRICE SCALE—METS 1965 HOME GAMES

Box Seats	$3.50
Reserved Seats	2.50

(Including All City and Federal Taxes)

INFORMATION FOR THE FOLLOWING—CALL NR 2-3000

Individual Ticket Purchase	Season Box Plan
Group Sales	Combination Plans

EASY WAYS TO BUY TICKETS IN ADVANCE

(After March 1, 1965)

	Weekdays	Saturdays	Sundays
Grand Central*	8:00-6:00	8:30-4:00	Closed
Penn Station**	8:00-6:00	8:30-4:00	Closed
Shea Stadium***	8:00-6:00	9:00-5:00	9:00-5:00
Macy★s****	Regular Store Hours		

*Foot of 42nd Street & Vanderbilt Avenue Ramp
**Long Island Waiting Room
***126th St. & Roosevelt Avenue
****Huntington, Long Island only

In addition, reservations for box and reserved seats may be made at all Howard Clothes stores during regular store hours. You may ORDER NOW BY MAIL for any MET home game as far in advance as you like. Tickets will be mailed well in advance of the game specified.

HOW TO ORDER BY MAIL

1. Specify date of game or games and the NUMBER and PRICE of Tickets desired.
2. Make check or money order payable to NEW YORK METS. (Please do not send cash or stamps.)
3. Add 25c for postage and handling charges.
4. Mail to Ticket Manager, Shea Stadium, Flushing, N.Y. 11368

GAME TIMES—1965

Game	Weekdays	Saturdays	Sunday
Single	2:00	2:00	2:00
Doubleheader	1:00	1:00	1:05
Night	8:00	8:00	—

Enjoy New York's favorite beer at home, wherever you dine, and at

SHEA STADIUM

Rheingold
EXTRA DRY
Lager Beer

©Metropolitan Baseball Club, Inc.

A ticket guide for Shea Stadium indicates the different ticket rates: $3.50 for box seats and $2.50 for reserved seats. Also listed are the locations throughout New York City that sell tickets, such as Macy's department store and Grand Central Station. (Author's collection.)

A NEW STADIUM IS BORN

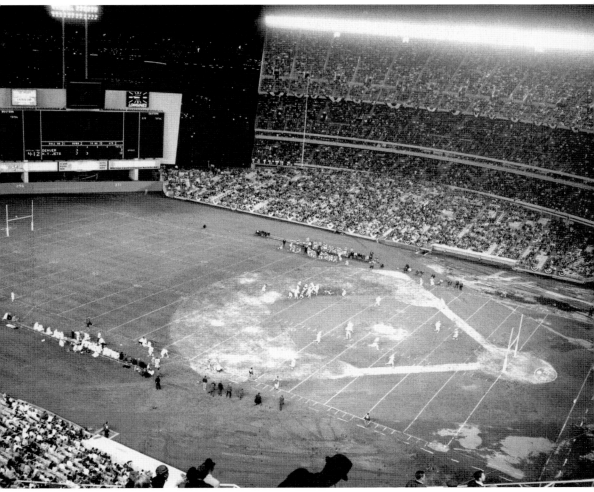

The New York Jets' first home game was against the Denver Broncos on Saturday, September 12, 1964, before a crowd of almost 60,000 people. The field-level seats have been moved in order for the game to be played. The Jets would go on to win the game 30-6. Reconfiguration of the field-level seats using the two sets of underground tracks took approximately 10 to 15 minutes. (Courtesy of the New York City Parks photograph archive.)

Although crowds flocked to the new state-of-the-art facility by the tens of thousands, there were games that were viewed by crowds under less than half capacity. Fans, rather than stick around and see their beloved Mets lose, would become tempted to leave where just across the street was the exciting nightlife of the world's fair. This photograph was taken on August 1, 1964. (Courtesy of United Press International.)

A NEW STADIUM IS BORN

SHEA STADIUM AND THE COMMUNITY

Flushing Meadows changed little for two and a half centuries after it was first settled, until the arrival of the Brooklyn Ash Removal Company. The 1939 world's fair rose from the ashes in Flushing Meadows over an area of 1,255 acres. The 1939 world's fair was a huge success and in 1961 a second fair was organized.

The 1964–1965 world's fair featured 150 pavilions and attractions showcasing the best of modern technology and the riches of the world's various cultures and resources. One of the most impressive attractions at the world's fair, which still exists today, is the New York City Panorama. The incredibly detailed model of New York City includes almost every one of its 840,000 buildings as well as every street, dock, bridge, and airport. It was built to scale and covers 18,000 square feet.

Shea Stadium, although not built specifically for the world's fair, had its opening delayed and rescheduled for April 1964 so it would open at the start of the festivities. Shea Stadium and the New York Mets became a huge part of going to the world's fair.

Since 1964, over 89,502,868 people have passed through the turnstiles at Shea Stadium. The team's main supporters are the residents of the two communities bordering the stadium: Flushing and Corona.

Flushing, located at the center of Queens, the largest of New York City's five boroughs, is the oldest continuously settled community in the area, founded on October 10, 1645. Located by Flushing Bay, the area was originally called Vlissingen, the Dutch word for "flowing water." Vlissingen was a seaport in the Netherlands. During the 1960s, many Japanese, Chinese, and Koreans settled in Flushing.

Originally called Newtown, Corona is a true example of the American melting pot. It is one of the most populated and most diverse communities in Queens. First developed in 1854, the area was named West Flushing and was home to only a dozen families and their farms. It was the arrival of the No. 7 train in 1917 that opened up Corona to all of New York City.

Corona attracted a large Latin community after World War II. Today the population is mainly Dominican, Colombian, Ecuadorian, and Chinese. Mexican storefronts are decorated in red, white, and green. Colombians decorate their homes in yellow, blue, and red, whereas Dominicans use red, white, and blue. Images like these make Corona and Flushing true cultural cornucopias of New York City.

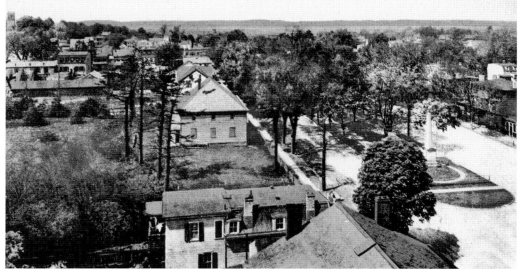

This gorgeous postcard shows a bird's-eye view of Broadway (Northern Boulevard) facing west. The photograph was taken in 1905 and shows the Quaker meetinghouse and Main Street on the left. On the right in the middle of the street is the Civil War memorial erected in 1866. (Courtesy of the Queens Borough Public Library, Long Island Division, Postcard Collection.)

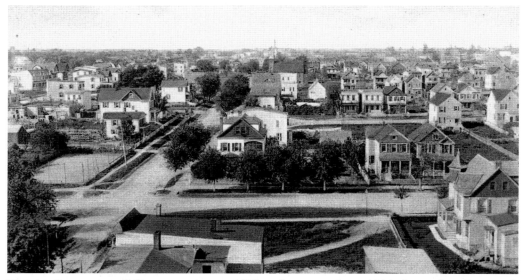

This bird's-eye view of Corona in August 1908, is facing north up 104th Street from Roosevelt Avenue before the elevated train was built. The once open farmland has now been divided up into lots and a large community has been established. Today the No. 7 train travels right through the middle of this scene. (Courtesy of the Queens Borough Public Library, Long Island Division, Postcard Collection.)

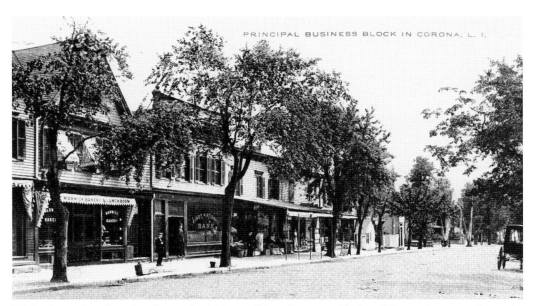

With the railroad station located within walking distance, National Street became the main shopping drag in Corona. Mom-and-pop stores line the block. Starting from the left is the Warwick Bakery and Lunchroom, the First National Bank, a local fruit stand, and an ice-cream parlor. This postcard photograph is from 1900. (Author's collection.)

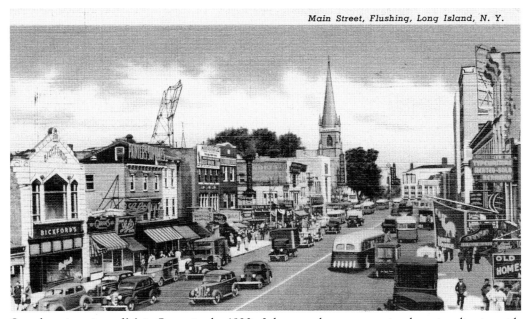

Seen here is a view of Main Street in the 1930s. It has now become a major shopping district with banks, restaurants, and clothing stores. At the foot of Main Street is St. George's Church and the RKO Keith's Theater. With the exception of period cars, Main Street looks almost identical today. Most of the signs now, however, are in Korean and Chinese dialects. (Author's collection.)

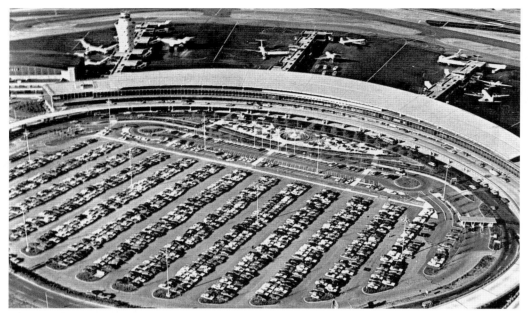

This aerial view of LaGuardia Airport was taken around the time of the opening of Shea Stadium. The architects failed to realize that the ballpark was being built directly in the flight path of airplanes leaving and arriving from the airport. (Author's collection.)

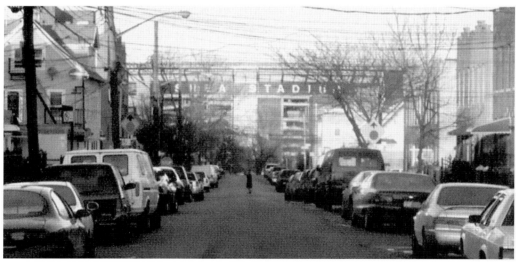

As the sun sets on Corona it bathes Shea Stadium in golden light. For 45 years, the ballpark has been a welcomed neighbor. Soon the view from this street will be a very different one when the new Citi Field will dominate the backdrop of one of Queens's most diverse neighborhoods. (Photograph by the author.)

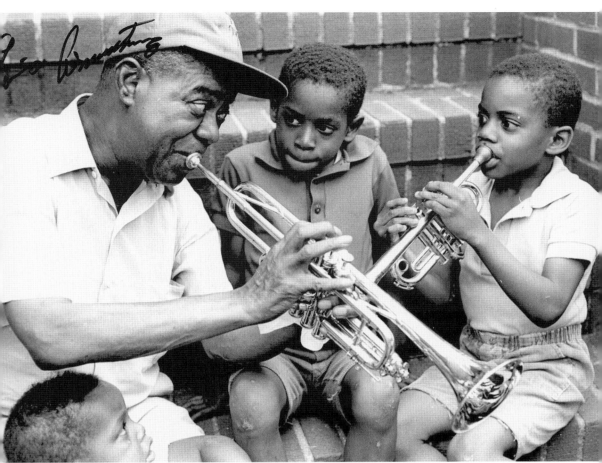

Music legend Louis "Satchmo" Armstrong moved into working-class Corona in 1943. He had spent so much time on the road that he never owned a house until his wife, Lucille, found this one. He lived the last three decades of his life here until he died in 1971. His final resting place is in Flushing Cemetery. Satchmo's house on 34–56 107th Street is now a museum. Louis Armstrong is pictured here on the front steps of what he called his "little pad" with the neighborhood children teaching them how to hold and play the trumpet. Notice the Mets hat that he is wearing. (Courtesy of the Louis Armstrong House and Museum Archives.)

The Grand Central Parkway was built in order to make the metropolitan area more accessible for the residents who lived in Nassau and Suffolk Counties in Long Island. Construction of the Grand Central Parkway began in July 1931 and cost $12 million. Its first major function was during the 1939 world's fair when it became the largest express route to the Manhattan area. Note the farmland surrounding the parkway. (Courtesy of the MTA Bridges and Tunnel Special Archive.)

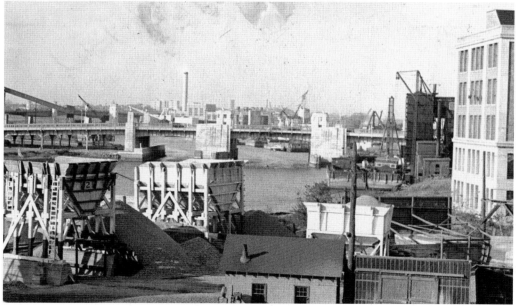

This is the dumping grounds for the Brooklyn Ash Removal Company. Flushing Creek flows underneath the Flushing Bridge in the background. Among the factories and flophouses would rise the 1939 world's fair. (Courtesy of the Queens Historical Society.)

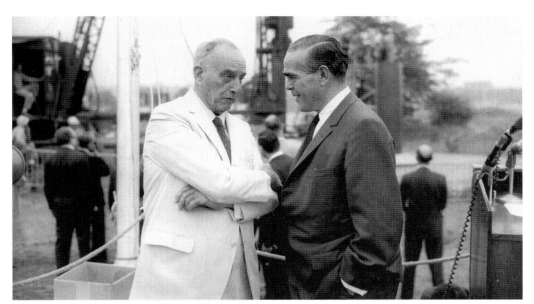

Robert Moses (left) meets with a fair supporter as construction of Shea Stadium proceeds in the background. Known as the "master builder" of New York City, Moses built many great structures throughout the city, including the Tri-Borough Bridge, the Bronx-Whitestone Bridge, and the 1964–1965 world's fair, which was the last great work in a lifetime of great architectural accomplishments. (Courtesy of the Queens Historical Society.)

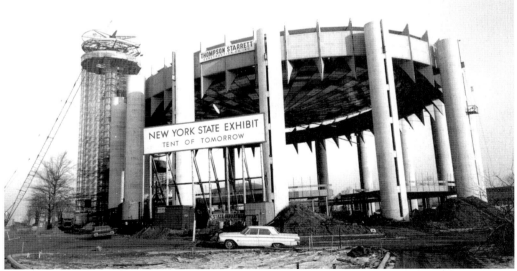

The centerpiece of the New York State pavilion was the Tent of Tomorrow. The structure housed a detailed map of the city and state of New York, created in mosaic tiles. The map was engineered by the pavilion's sponsor, Texaco, and was constructed by the Thompson Starret Construction Company. This photograph was taken on December 17, 1963. (Courtesy of the Queens Historical Society.)

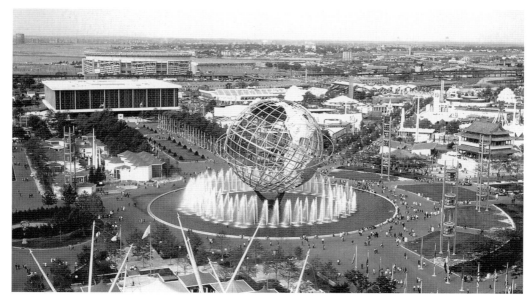

In the center of this view of the 1964–1965 world's fair is the 12-story-high stainless steel Unisphere, which was the symbol of the fair's theme: Peace through Understanding. In the background are the numerous pavilions, which include the Republic of China pavilion, Caribbean pavilion, and the Greece pavilion. Shea Stadium dominates the far left background. (Courtesy of Bill Cotter.)

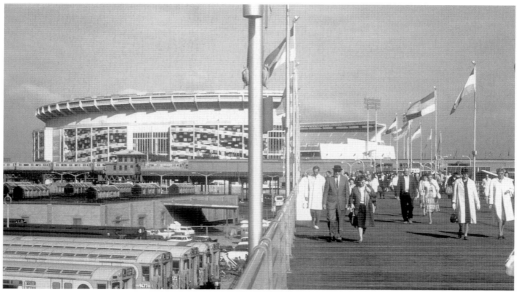

This is the No. 7 line that connects the trains from Times Square and Corona to the Main Street Flushing station of the IRT. Crossing over the platform are passengers disembarking the No. 7 train and heading toward the world's fair. Shea Stadium stands proudly in the distance. To the left is the rail yard for the IRT. This photograph was taken on September 26, 1965. (Courtesy of Bill Cotter.)

SHEA STADIUM AND THE COMMUNITY

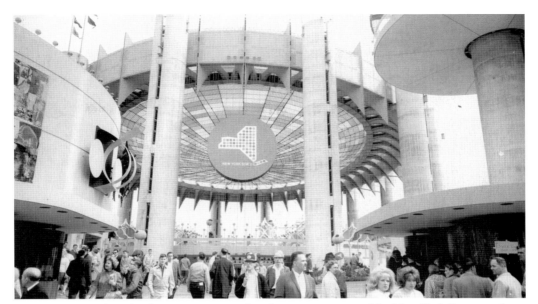

Fairgoers wait in line for their turn to enter the observation tower of the New York State pavilion. The cost for admission was 50¢. This photograph was taken on opening day, April 22, 1964. The maximum height of the tallest tower was set by federal aviation authorities at 226 feet because of the fair's proximity to LaGuardia Airport. (Courtesy of the Queens Historical Society.)

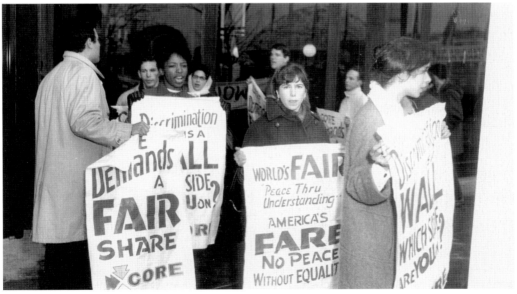

The Congress of Racial Equality, or CORE, marches in front of the world's fair in April 1964. The organization was on hand to protest the existence of the fair and its message of "Peace through Understanding," which was seen as hypocritical because of segregation and the fact that African Americans still could not yet vote. Other forms of protest happened in front of the Shea Stadium ticket offices as people arrived for games. (Courtesy of the Queens Historical Society.)

Pres. John F. Kennedy was a major supporter of the world's fair and gave it his blessing. In a letter to Robert Moses dated October 5, 1961, Kennedy wrote, "I have written the Mayor [Robert Wagner] assuring him of my support of the World's Fair, which under your direction and leadership will be I am sure, most successful. You can be sure of my continued interest and the support of the Administration. I hope to be with you at the ribbon cutting." Kennedy was assassinated on November 22, 1963. (Author's collection.)

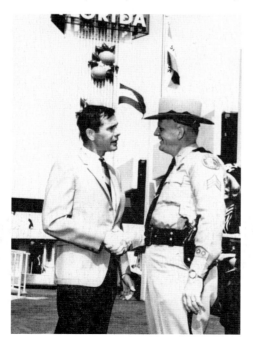

The Tonight Show host Johnny Carson is shown here visiting the Florida pavilion. Behind him is the 110-foot Florida tower, which was topped by a huge plastic orange. Carson released an album titled *Johnny Carson's Introduction to New York City and the 1964–1965 World's Fair*. (Author's collection.)

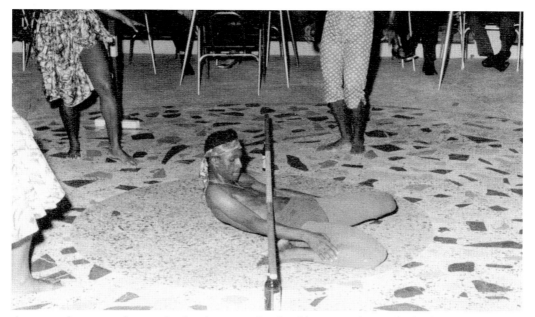

A native dancer performs a limbo dance at the Caribbean pavilion, which also featured steel bands and calypso singers. (Author's collection.)

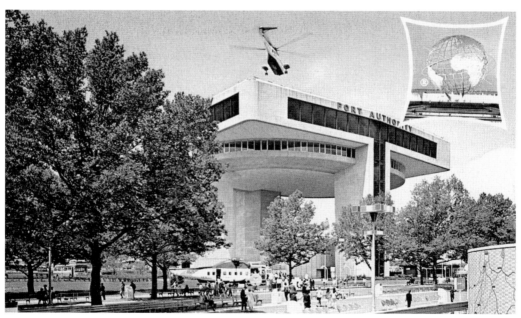

Port Authority Heliport was the aerial gateway to the fair. Rising 120 feet above the ground on four mammoth tapered columns, it included a heliport, restaurant, and open bar. Helicopters providing sightseeing tours between the fair and Manhattan would land on the roof, which housed a 150-by-200-foot landing pad. Although the heliport is no longer in use, this structure still remains and has been renamed Terrace on the Park. (Courtesy of Dexter Press.)

SHEA STADIUM

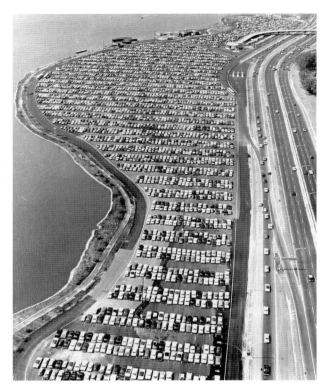

The fair drew large crowds. Exactly 51,766,300 people came to the fair. The total investment in the project came to a staggering $1 billion. This parking lot just north of the fairgrounds, which was also used as an alternative parking lot for Shea Stadium, provided free busing to and from the fair. The overwhelming amount of cars is an example of the daily congestion at the fair. (Author's collection.)

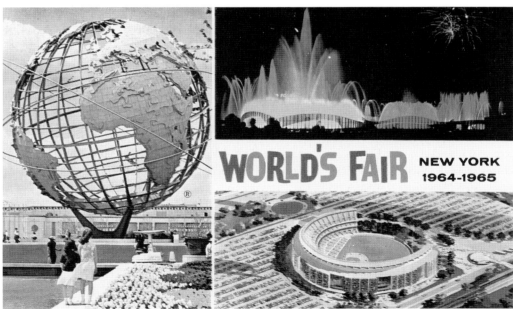

This postcard sold at the fair shows the Unisphere and the famous fireworks show. On the bottom right is an advertisement for Shea Stadium, which was part of the world's fair attractions. The world's fair closed its doors on October 17, 1965. (Courtesy of Dexter Press.)

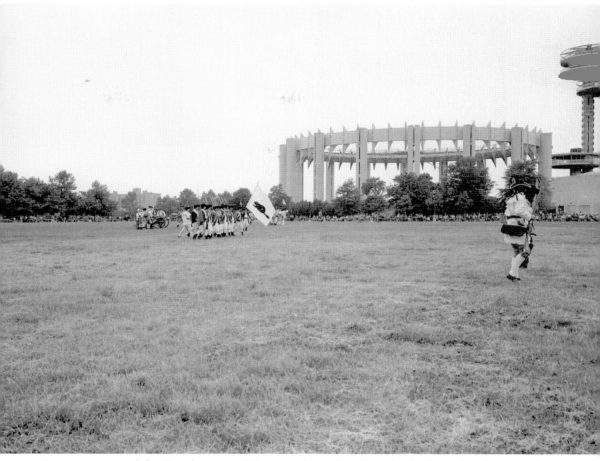

A reenactment of the Revolutionary War is performed on Fourth of July weekend during the bicentennial in 1976. The abandoned New York State pavilion is seen in the background. In a major contrast to the previous photographs all the other pavilions are gone and only grassy fields remain. Only a few clues are left to indicate that the fair ever existed. The poet Ogden Nash wrote in his poem about Robert Moses and the 1964–1965 world's fair, "Nobody departs, until it closes, from the Promised Land of Mr. Moses." (Courtesy of the Queens Borough Public Library, Long Island Division, Joseph A. Ullman Photographs.)

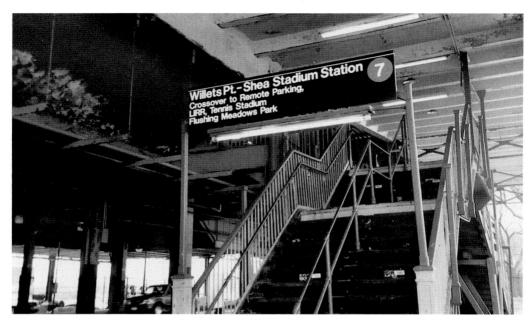

These steps lead from the Willets Point–Shea Stadium Station platform. Below is Roosevelt Avenue. The classic purple No. 7 logo is on the right. (Photograph by the author.)

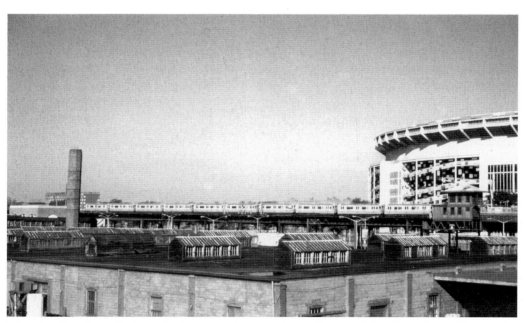

The No. 7 train pulls into the Willets Point station delivering Mets fans from all over the metropolitan area in this photograph taken on September 26, 1965. The mint green cars were soon replaced by the classic redbirds, which were finally replaced by generic steel gray cars in 2003. (Author's collection.)

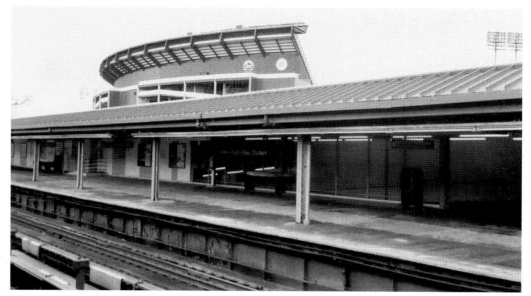

The 100-year-old No. 7 line platform will soon show signs marking the stop as Willets Point–Citi Field. Shea Stadium can be seen rising in the background. The Mets logo is next to the parks department logo. (Photograph by the author.)

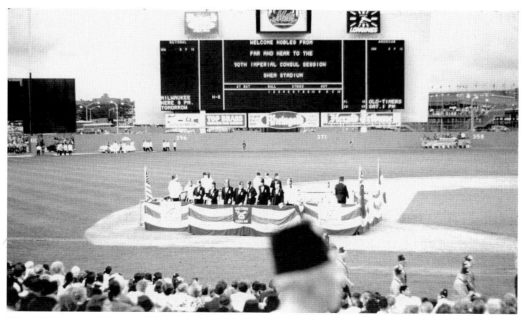

The 90th annual Imperial Consul Session of Shriners was held at Shea Stadium in May 1964. The scoreboard welcomes "nobles from far and near." A grandstand has been set up on top of third base. The Shriners often participate in local parades and hold public gatherings. (Courtesy of Bill Cotter.)

The Nobles, wearing their signature fez hats, and an "Oriental Band" dressed in cartoonish versions of Middle Eastern dress, pipe bands, and drummers march in a victory lap around the field. A large crowd of almost 20,000 is in attendance. (Courtesy of Bill Cotter.)

The Nobles were an organization made up of veterans of foreign wars, union workers, ex-police officers, and other members of public service. The victory lap continues as some members ride horseback along the third-base line. (Courtesy of Bill Cotter.)

SHEA STADIUM AND THE COMMUNITY

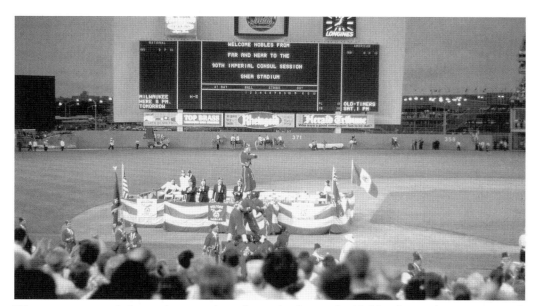

The program concludes with a grand acrobatic display as the Nobles form a human pyramid. (Courtesy of Bill Cotter.)

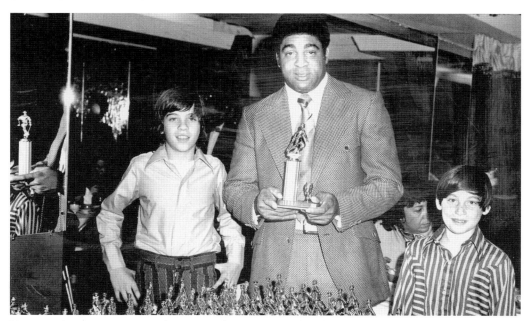

Tommie Agee passes out trophies to Little Leaguers at the Flushing Little League Annual Trophy Awards banquet at the Sun Luck Restaurant in Queens on November 1, 1971. On April 10, 1969, Agee hit a home run into the left field upper deck, which remains today the highest homer hit in Shea Stadium history. A large circle where he hit his home run stating his name, number, and the date was painted where the homer landed. (Courtesy of the Queens Borough Public Library, Long Island Division, Joseph A. Ullman Photographs.)

New York Mets announcer Ralph Kiner (center) attends the Flushing Boys Club luncheon at the Diamond Club at Shea Stadium. This photograph was taken on July 1, 1975. (Courtesy of the Queens Borough Public Library, Long Island Division, Joseph A. Ullman Photographs.)

Tom Seaver also attended the Flushing Boys Club luncheon at the Diamond Club. Here lucky members pose with "Tom Terrific" on July 1, 1975. (Courtesy of the Queens Borough Public Library, Long Island Division, Joseph A. Ullman Photographs.)

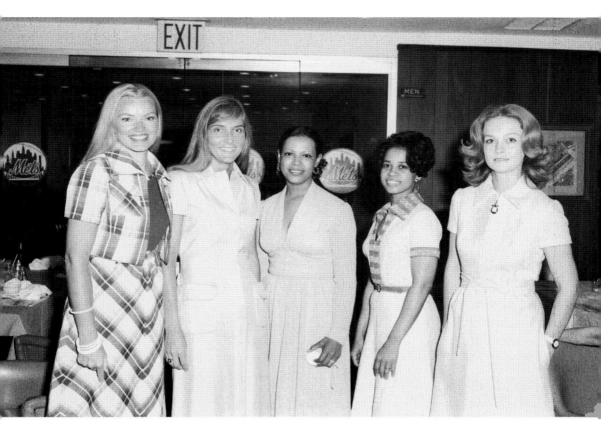

A group from the Doctors Wives Auxiliary, attending Flushing Hospital's 10th Anniversary Luncheon and Fashion Show, poses for this photograph in Shea Stadium's Diamond Club in 1973. (Courtesy of the Queens Borough Public Library, Long Island Division, Joseph A. Ullman Photographs.)

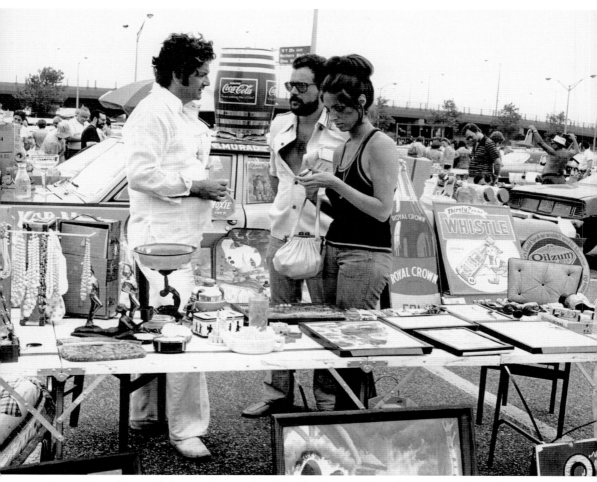

An antique show and flea market in the Shea Stadium parking lot is pictured in the summer of 1973. Large or even smaller local events like these show the ballpark's versatility with the community. (Courtesy of the Queens Borough Public Library, Long Island Division, Joseph A. Ullman Photographs.)

SHEA STADIUM AND THE COMMUNITY

SHEA STADIUM'S GREATEST MOMENTS AND PLAYERS

Since the 1964 All-Star Game up to the 2006 National League Championship Series, Shea Stadium has been the setting for many great moments in baseball. In their illustrious history, the Mets have captured five Eastern Division titles, two wild cards, three division series, four National League pennants, and two World Series titles. On October 16, 1969, the team won its first world championship with a 5-3 victory over the Baltimore Orioles before 57,397 screaming fans at Shea. After the game, the fans poured onto the field tearing up the turf in a display of exuberance never before seen in baseball. The 1969 Mets had some of the most talented and legendary players in baseball. Pitcher Tom Seaver joined the Mets in 1967. In 1969, Seaver won 24 games. During his career with the Mets, Seaver won four National League Cy Young Awards, in 1967, 1969, 1973, and 1975. The late pitcher Frank "Tug McGraw" propelled the Mets to the 1973 World Series with his performance on the mound and his motivating battle cry, which became the team's motto: "Ya Gotta Believe!"

Shea Stadium is one of the most community-oriented ballparks. The stadium has been rented out by religious groups for public services as well as for local soccer tournaments, antique shows, and even the pope's visit in 1979.

Because of its detachable seating, Shea Stadium has been the site of numerous concerts, including the Beatles (1965 and 1966); the Ice Capades (1967); Billy Graham (1970); the Summer Festival for Peace, with appearances by Jimi Hendrix and Janis Joplin; Grand Funk Railroad (1971); the Who (1982); and Simon and Garfunkel (1983). The Rolling Stones played six sold-out concerts in October 1989. The New York Jets, who also called Shea Stadium home from 1964 until 1983, won the AFL Championship 27-23 against the Oakland Raiders on December 29, 1968.

In October 1986, the Mets did it again. The Mets entered the fall classic against the Boston Red Sox as the underdog. In one of the greatest comebacks in sports history, the Mets were only one strike away from annihilation in Game 6. After miraculously tying the game, Mookie Wilson hit a ground ball right through first baseman Bill Buckner's legs and forced the decisive seventh and final game. Delayed one day by rain, the Mets defeated the Boston Red Sox 8-5 in Game 7 at Shea Stadium to become world champions for the second time in franchise history.

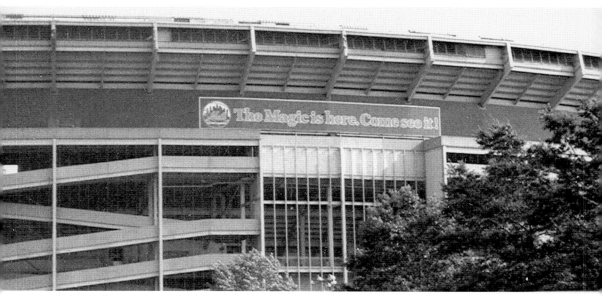

"The Magic is here. Come see it!" shouts the slogan banner atop Shea Stadium. The slogan is a custom and changes every year. Shea Stadium has indeed been the home of many amazin' moments in sports and local history. (Courtesy of Carl Abraham.)

One of the longest games in baseball history occurred on Sunday, May 31, 1964, at Shea Stadium in a game between the Mets and the San Francisco Giants. The game stretched out to 23 innings, with the Giants winning 8-6. The scoreboard announces that this was the longest game played in the National League that year. (Photograph by John J. Lent; courtesy of AP/Wide World Photos.)

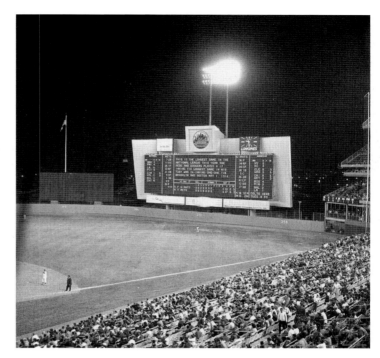

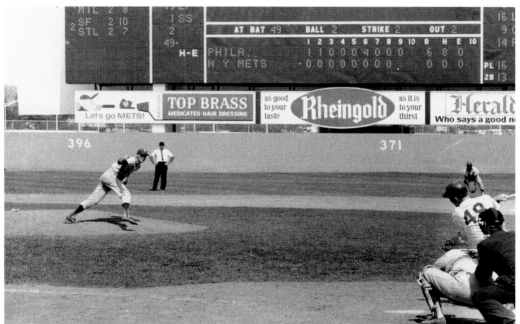

Philadelphia Phillies right-handed pitcher Jim Bunning strikes out pinch hitter John Stephenson of the Mets in the ninth inning for the final out of a perfect no-hit game at Shea Stadium on Sunday, June 21, 1964. The catcher pictured at right is Gus Triandos. The Phillies won 6-0. (Photograph by Harry Harris; courtesy of AP/Wide World Photos.)

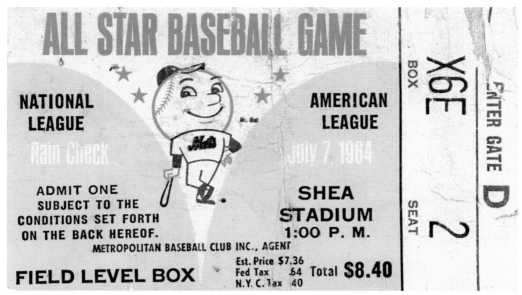

A ticket to the 1964 All-Star Game is seen here. Over 50,850 fans came out to Shea Stadium for what would be the only time in history that the ballpark ever hosted the midseason classic. The National League won the game 7-4 after a dramatic four-run rally in the bottom of the ninth inning including Johnny Callison's game-winning three-run homer. The ticket cost only $8.40 for field-level seating. (Author's collection.)

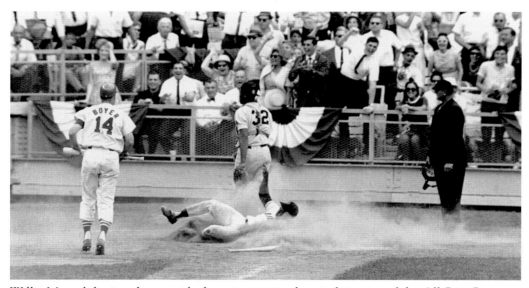

Willie Mays slides into home with the tying run in the ninth inning of the All-Star Game on July 7, 1964. The San Francisco all-star was walked, stole second, and then scored on Joe Pepitone's throwing error, setting the stage for Johnny Callison's three-run homer that gave the National League its victory. Catcher Elston Howard (No. 32) of the New York Yankees turns to retrieve the ball. At left is Ken Boyer of the St. Louis Cardinals. (Courtesy of AP/Wide World Photos.)

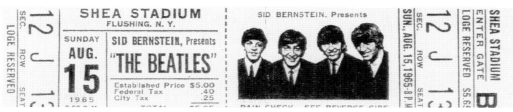

A new world record for a pop concert was created when more than 55,000 fans attended this legendary outdoor concert at Shea Stadium in 1965. The Beatles also set a world record with their $160,000 share of the $304,000 gross receipts. The show was filmed by Ed Sullivan Productions for a 50-minute television special that the BBC first aired on March 1, 1966. This official ticket stub for the Beatles concert features a smiling Fab Four. The cost of admission was only $5.65. (Author's collection.)

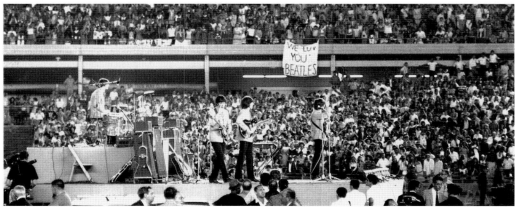

This amazing photograph shows the Beatles onstage in center field on Sunday, August 15, 1965. In the background are the roaring 55,000 fans that came out to see John, Paul, George, and Ringo. The noise was absolutely deafening. This was one of the first stadium concerts in the United States. (Photograph by Dan Farrell; courtesy of the New York Daily News.)

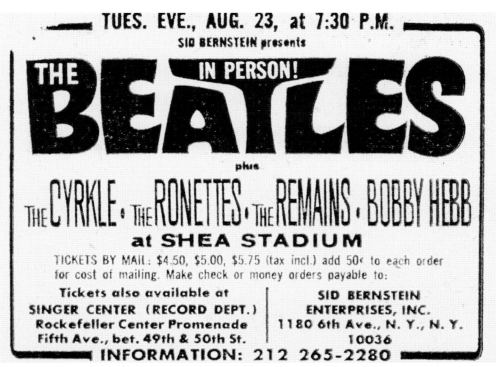

TUES. EVE., AUG. 23, at 7:30 P.M.

SID BERNSTEIN presents

THE BEATLES

IN PERSON!

plus

The CYRKLE · The RONETTES · The REMAINS · BOBBY HEBB

at SHEA STADIUM

TICKETS BY MAIL: $4.50, $5.00, $5.75 (tax incl.) add 50¢ to each order for cost of mailing. Make check or money orders payable to:

Tickets also available at
SINGER CENTER (RECORD DEPT.)
Rockefeller Center Promenade
Fifth Ave., bet. 49th & 50th St.

SID BERNSTEIN
ENTERPRISES, INC.
1180 6th Ave., N. Y., N. Y.
10036

INFORMATION: 212 265-2280

This newspaper advertisement is for the Beatles' second legendary concert at Shea Stadium in 1966. Even with 11,000 unsold tickets, the Fab Four still drew a crowd of 45,000 and grossed $292,000 in ticket sales. The price for the ticket was $4.50, $5.00, or $5.75. Other performing bands that night included the Crykle, the Ronettes, and the Remains with Bobby Herb. (Author's collection.)

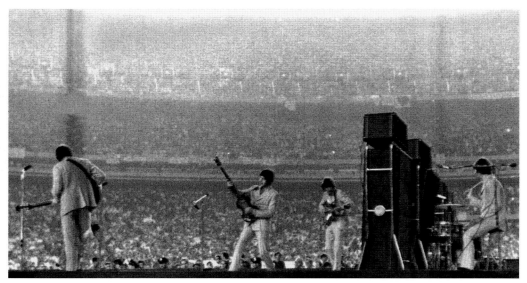

The Beatles perform their second concert at Shea Stadium before a crowd of 45,000 people on Tuesday, August 23, 1966. (Courtesy of AP/Wide World Photos.)

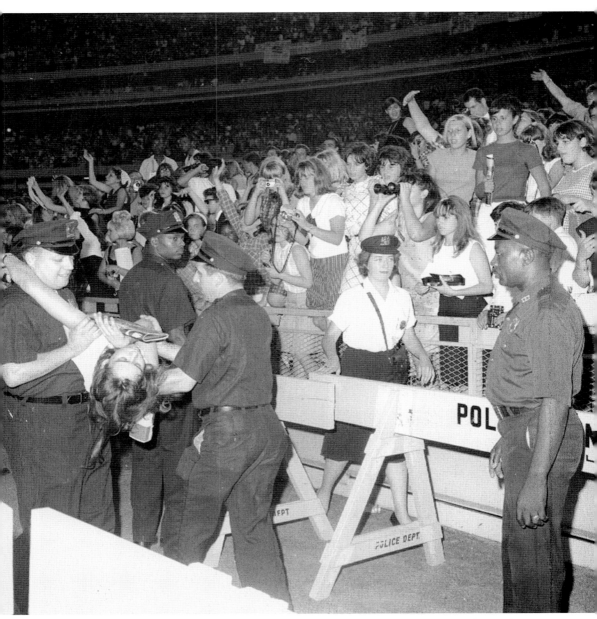

No doubt overcome by the soulful renderings, this teenager is carried off the field after fainting during the Beatles' first concert. The crowd in the background is going crazy. The noise was so deafening that most people in attendance could not even hear the music. (Photograph by Jim Hughes; courtesy of the New York Daily News.)

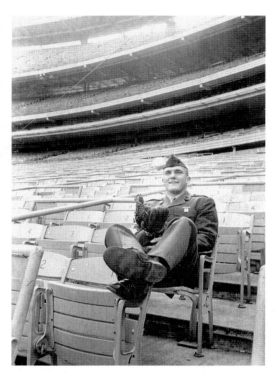

Frank "Tug" McGraw, on leave from Marine Corps training at Camp Lejeune, North Carolina, visits Shea Stadium on January 18, 1965. He made his major-league debut with the Mets that year at age 20. McGraw was best known for his slogan "You Gotta Believe!" during the Mets' 1973 run for the World Series. A two-time all-star, McGraw went 96-92 in his career with a 3.14 ERA and 180 saves. McGraw finished his career with the Phillies in 1984. He is also the father of country music star Tim McGraw and died on January 5, 2004, at age 59. (Courtesy of AP/Wide World Photos.)

Tom Seaver joined the Mets in 1967. He won 16 games for the last-place team, with 18 complete games, 170 strikeouts, and a 2.76 ERA. Seaver was named Rookie of the Year and was his team's representative at the 1967 All-Star Game. In 1969, "the Franchise" won 35 games and earned his first National League Cy Young Award. Seaver played for the Mets until 1977 when he was traded to the Reds in what was called "the Midnight Massacre." He returned for one final season at Shea Stadium in 1983. He is the only player to be inducted into the National Baseball Hall of Fame as a Met. (Courtesy of the Corbis/Bettmann Archives.)

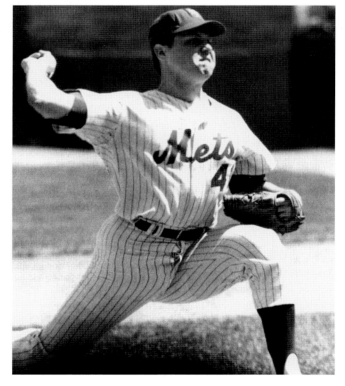

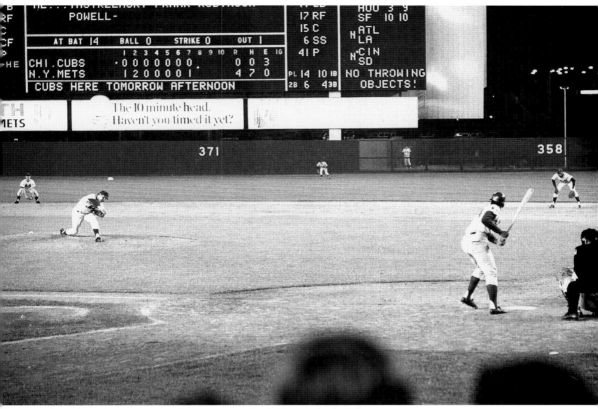

Tom Seaver, left, is working on a no-hitter in the eighth inning on Tuesday, July 9, 1969. Seaver's bid for a perfect game was spoiled after eight and one-third innings when outfielder Jimmy Qualis lined a single to left. The Mets won 4-0. (Courtesy of AP/Wide World Photos.)

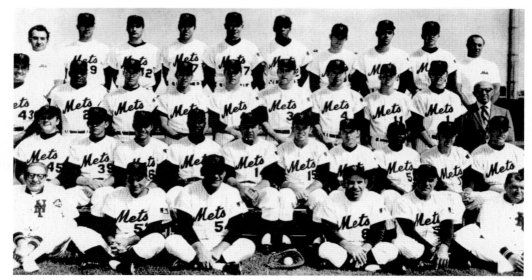

This is the team photograph of the 1969 world champion New York Mets. The team featured Frank "Tug" McGraw, Gary Gentry, Al Weis, Cleon Jones, Jerry Grote, Bud Harrelson, Ed Charles, Rod Gaspar, Tommie Agee, Ken Boswell, Tom Seaver, Jerry Koosman, Ron Swoboda, Donn Clendenon, Wayne Garrett, J. C. Martin, Ed Kranepool, Nolan Ryan, and Art Shamsky. (Courtesy of the New York Mets.)

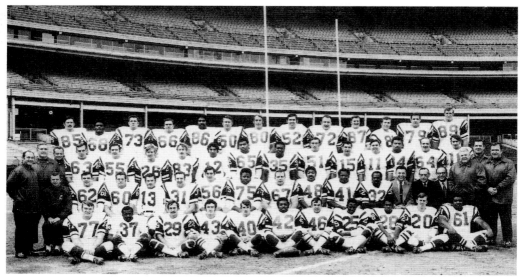

Shea serves as the backdrop in this team photograph of the 1969 Eastern Division champion New York Jets. Gang Green won Super Bowl III against the Baltimore Colts 16-7 in one of the greatest upsets in football history. (Courtesy of the New York Jets.)

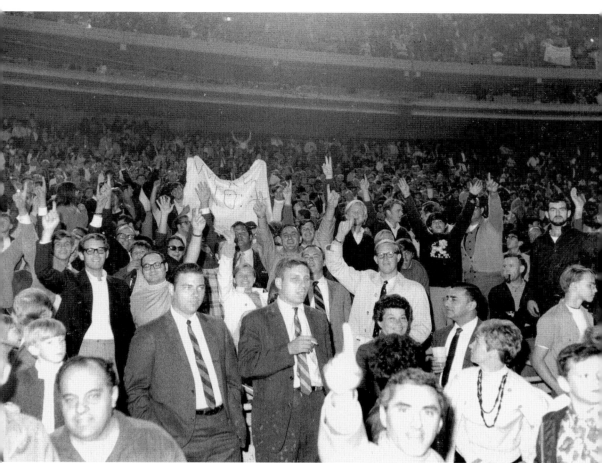

"The New Breed" goes crazy as a crowd of almost 50,000 are on hand to witness the Mets reach first place for the first time in franchise history. Banners reading "We're No. 1" wave in the background as fans give victory signs. The scoreboard flashed the famous announcement "Look who's number one!" after the Mets defeated the Montreal Expos 4-0 on Wednesday, September 10, 1969. (Courtesy of AP/Wide World Photos.)

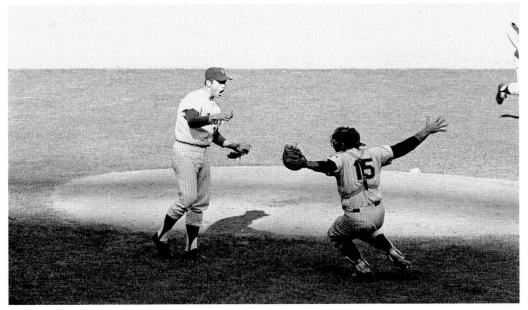

New York Mets pitcher Nolan Ryan, left, and catcher Jerry Grote rush toward each other after the Mets won their first pennant with a three-game sweep and a 7-4 victory over the Atlanta Braves on Monday, October 6, 1969. This would be Ryan's only appearance in postseason play. The best of five was also the first National League Championship Series in baseball. (Courtesy of AP/Wide World Photos.)

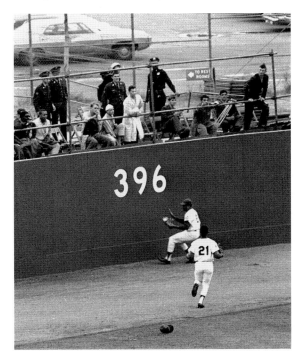

Mets center fielder Tommie Agee grabs a drive hit by Baltimore Oriole Elrod Hendricks during the fourth inning of Game 3 of the 1969 World Series. Moving in on the play is teammate Cleon Jones. Watching this amazing play just above the center field fence is a group of wounded Vietnam veterans who were specially brought out to watch the game. (Courtesy of AP/Wide World Photos.)

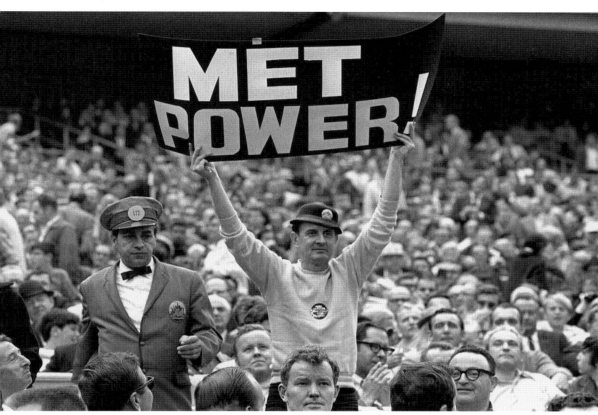

Who could ever forget Karl Ehrhardt, the New York Mets fan known as "the Sign Man"? Ehrhardt is shown here holding up a Met Power! sign after Ed Kranepool hit a home run in the eighth inning of the third game of the World Series on Tuesday, October 14, 1969. The Mets shut out the Orioles 5-0. (Courtesy of AP/Wide World Photos.)

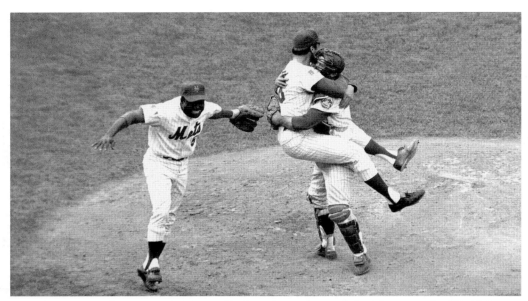

In 1969, two miracles occurred. Man walked on the moon, and the Mets won the World Series! Catcher Jerry Grote embraces pitcher Jerry Koosman as the Mets defeated the Baltimore Orioles in Game 5 to win the World Series on Thursday, October 16, 1969. At left is teammate Ed Charles. (Courtesy of AP/Wide World Photos.)

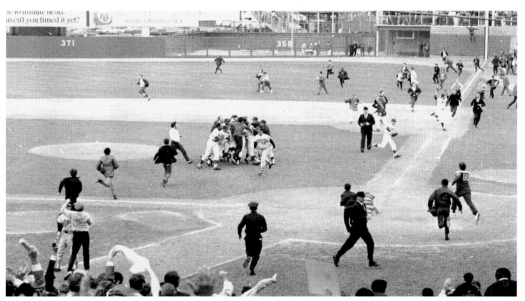

Fans stream onto the field at Shea Stadium as the New York Mets celebrate after defeating the Orioles 5-3 in Game 5 to win the 1969 World Series and their first world championship. Jubilant fans storming the field like this would become a tradition in baseball throughout the 1970s and 1980s. Due to insurance and safety issues Major League Baseball prohibits acts of this nature in modern-day games. (Courtesy of AP/Wide World Photos.)

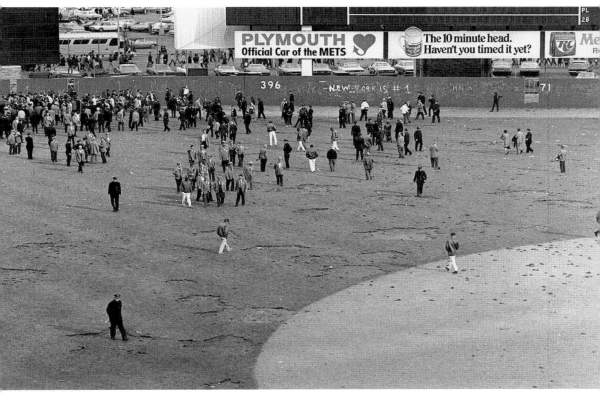

This amazing photograph shows the infield and outfield of Shea turned into a pockmarked terrain after souvenir-hunting fans ripped up the sod following the Mets' victory in the World Series. The outfield wall has been covered with graffiti while victory-happy Mets fans exit through the center field wall into the parking lot away from the virtually destroyed playing field. Some of the "artwork" on the outfield fence included "Champions" and "New York is #1." (Courtesy of AP/Wide World Photos.)

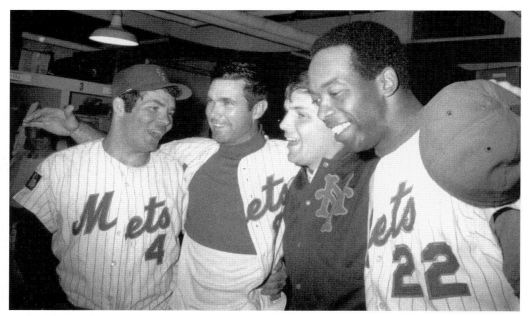

From left to right, Ron Swoboda, J. C. Martin, Tom Seaver, and series MVP Donn Clendenon celebrate with their teammates in the locker room after winning their first World Series. (Author's collection.)

Rheingold Beer was the official sponsor of the New York Mets since their first season. Here in its new advertisement campaign, Rheingold features itself as the official sponsor of the world champion Mets. (Author's collection.)

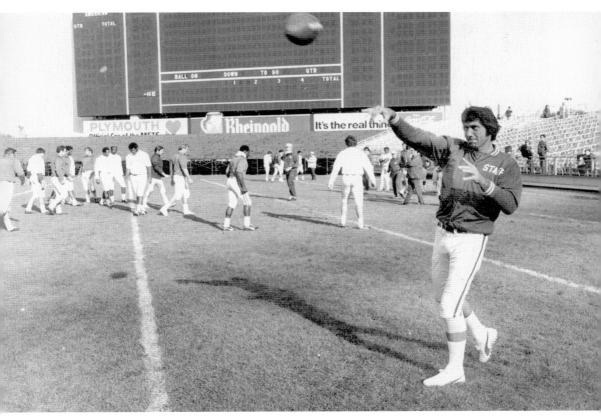

New York Jets quarterback Joe Namath is shown here passing the ball during his first practice workout at Shea since his August 7 leg injury. This photograph was taken on October 12, 1971. Namath's career with the Jets lasted from 1965 to 1976. "Broadway Joe" threw 173 touchdown passes and 220 interceptions. (Courtesy of AP/Wide World Photos.)

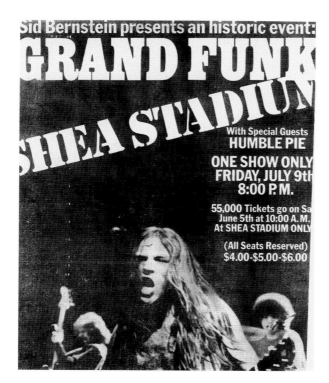

Grand Funk Railroad made an appearance at Shea Stadium on Friday, July 9, 1971. This newspaper advertisement shows the group's members Mel Schacher, Don Brewer, and Mark Farner. (Author's collection.)

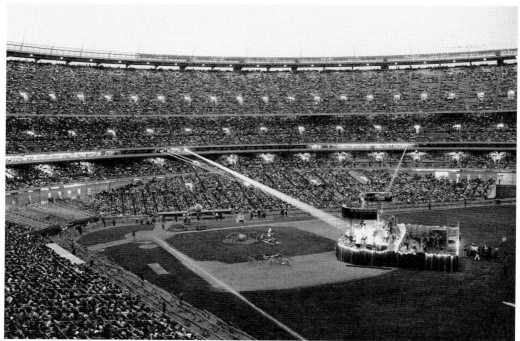

Grand Funk Railroad sold out faster than the Beatles did when the group sold 55,000 tickets in just 72 hours. (Photograph by Charles Ruppmann; courtesy of the New York Daily News.)

Jethro Tull and Robin Trower appeared at Shea Stadium on Friday, July 23, 1976. (Author's collection.)

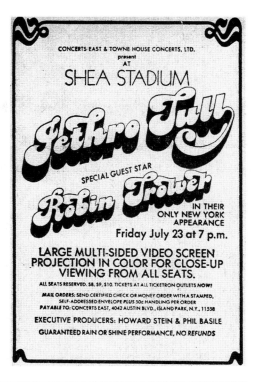

The 1973 New York Mets won the National League pennant against the Cincinnati Reds. Key players on the team that season were Frank "Tug" McGraw, Tom Seaver, Dave Kingman, and Willie Mays in his final season. New team manager Yogi Berra took over after Gil Hodges died of a heart attack in 1972 during spring training. (Courtesy of the New York Mets.)

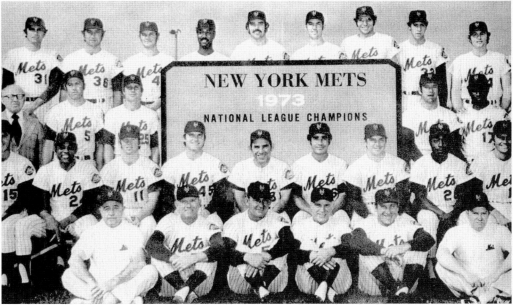

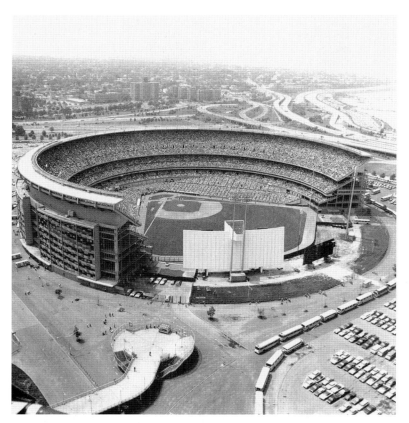

Shea Stadium became packed as the Mets began a slow but steady climb out from the cellar in the summer of 1973. This aerial view shows a packed parking lot and a near-sell-out crowd of 47,800. (Courtesy of AP/Wide World Photos.)

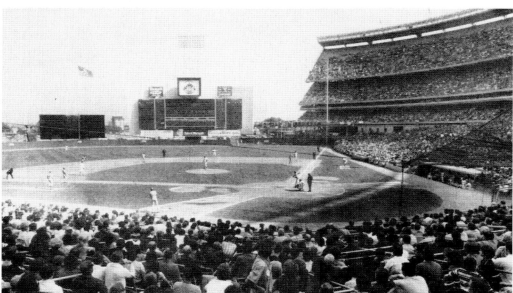

The Mets drew enormous crowds in 1973, making a record attendance that year of 1,912,390 fans. (Author's collection.)

SHEA STADIUM'S GREATEST MOMENTS AND PLAYERS

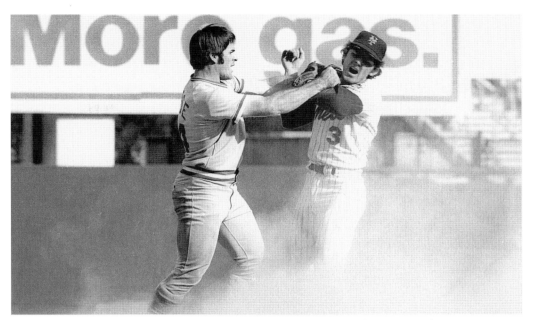

Things heated up in Game 3 of the National League Championship Series when Pete Rose of the Cincinnati Reds punched Mets shortstop Bud Harrelson on Monday, October 8, 1973. Both benches and bull pens emptied in the ensuing brawl. (Photograph by Marty Lederhandler; courtesy of AP/Wide World Photos.)

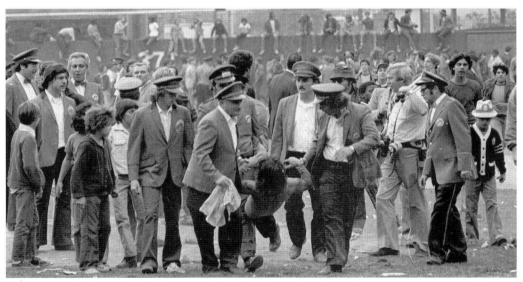

Shea Stadium personnel carry off one of the spectators who was injured on the playing field when the crowd poured from the stands following the New York Mets 7-2 win over the Cincinnati Reds in the final game on Wednesday, October 10, 1973. This display of fan exhilaration was different from the display in the 1969 World Series. Numerous arrests were made as fights and rowdiness broke out in the melee of fans. (Courtesy of AP/Wide World Photos.)

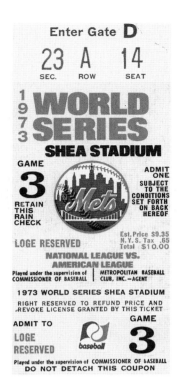

This ticket stub was for Game 3 of the 1973 World Series against the Oakland Athletics on Tuesday, October 16. The Mets lost 3-2 in 11 innings. Price of admission was only $10 dollars for loge reserved seating. This was the first home game at Shea Stadium for the series, which the Mets would unfortunately go on to lose in seven games. (Author's collection.)

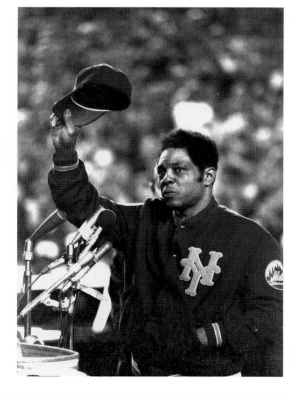

New York Mets outfielder Willie Mays tips his hat to the fans for the last time during farewell ceremonies for him at home plate on Wednesday, September 26, 1973. The Mets added to Mays's send-off by downing the Montreal Expos 2-1. Mets owner Joan Whitney Payson, along with a sold-out crowd, was on hand to wish him well. The illustrious career of the "Say Hey Kid" began when Mays broke into the big leagues at 20 years old on May 25, 1951, with the New York Giants. He batted a career 660 home runs and 3,283 hits. (Photograph by Ray Stubblebine; courtesy of AP/Wide World Photos.)

The Atlanta Braves' slugging outfielder Hank Aaron stands at home plate at Shea Stadium on Monday, June 17, 1974, during Hank Aaron Night pregame ceremonies. The Mets gave Aaron a rocking chair, which he said he hoped he would not need for a while. Aaron is the all-time home run champion with 755. (Photograph by Ray Stubblebine; courtesy of AP/Wide World Photos.)

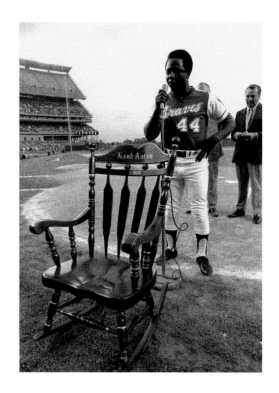

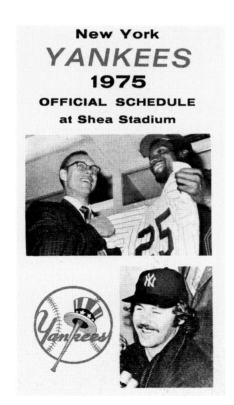

In 1972, the Yankees sold their stadium to New York City and signed a 30-year lease. During the 1974–1975 season, they played all their home games at Shea Stadium while major renovations were made. These were the first home games outside Yankee Stadium since 1922. Shown here is the 1975 official schedule for the New York Yankees at Shea Stadium. The schedule pamphlet shows new player Bobby Bonds (above) and National Baseball Hall of Fame pitcher Jim "Catfish" Hunter. (Author's collection.)

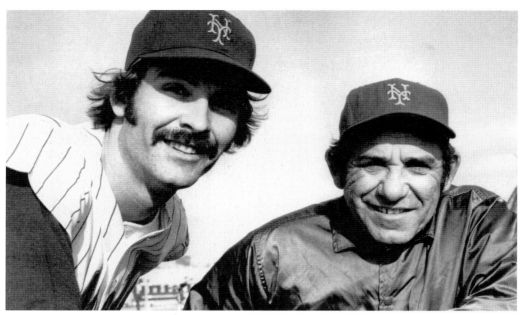

Dave Kingman and manager Yogi Berra are pictured at spring training in 1975. This was Kingman's first season with the Mets. His performance was phenomenal. That year he batted .231, hitting 36 home runs, 116 hits, and 88 RBIs. (Author's collection.)

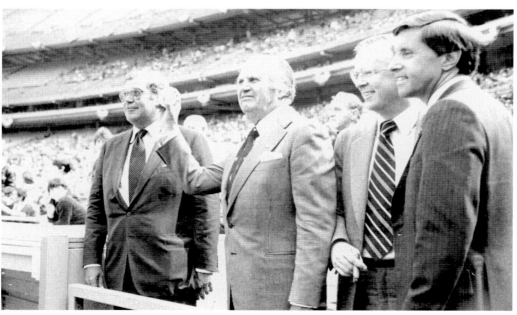

William A. Shea throws out the first pitch on opening day 1980. Board chairman Nelson Doubleday is to Shea's right while director and team president Stephen O'Neil and Mets owner Fred Wilpon are on his left. (Courtesy of the Queens Borough Public Library, Long Island Division, Illustrations-Sports/Baseball.)

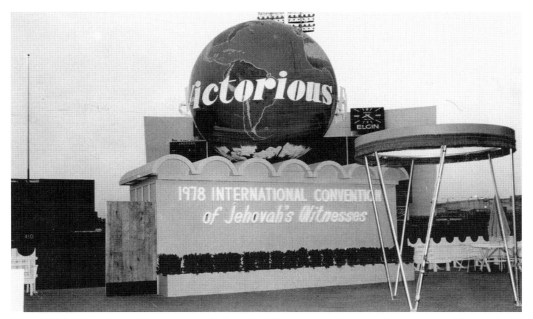

The 1978 International Convention of Jehovah's Witnesses at Shea Stadium occurred from July 12 through July 16, 1978. (Courtesy of the Queens Borough Public Library, Long Island Division, Joseph A. Ullman Photographs.)

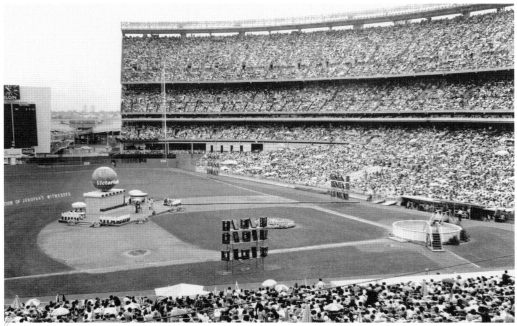

The 1978 International Convention of Jehovah's Witnesses sold out the entire ballpark. A pool for baptizing the faithful has been placed directly over home plate. (Courtesy of the Queens Borough Public Library, Long Island Division, Joseph A. Ullman Photographs.)

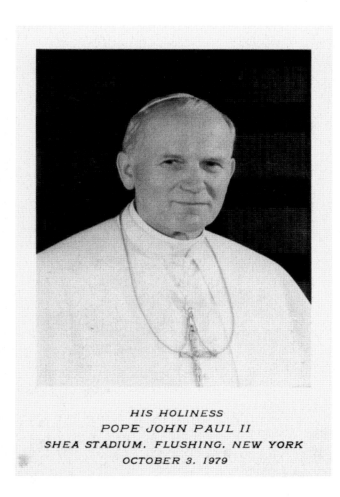

His holiness, Pope John Paul II visited Shea Stadium during his New York City tour on Wednesday, October 3, 1979. (Author's collection.)

HIS HOLINESS
POPE JOHN PAUL II
SHEA STADIUM. FLUSHING. NEW YORK
OCTOBER 3. 1979

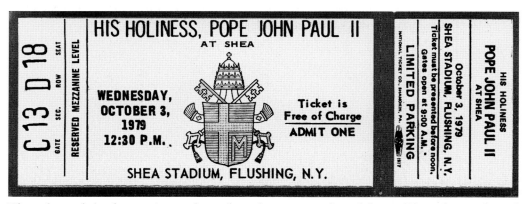

The ticket stub for the pope's visit shows that admission was free of charge. The ticket is adorned with the papal seal. (Author's collection.)

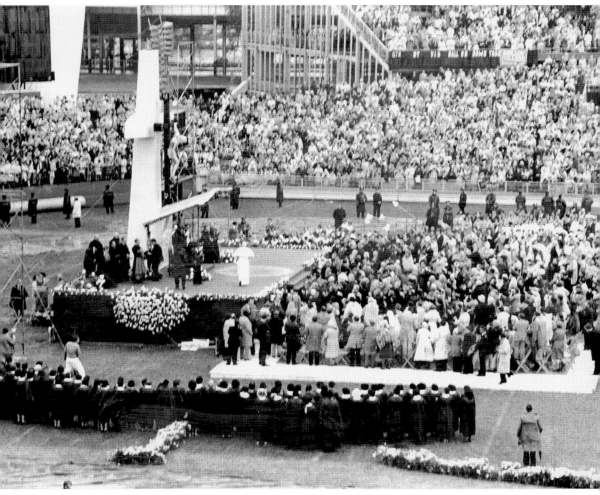

Pope John Paul II walks onto the stage specially prepared for him in center field. Over 60,000 people turned out to see him at Shea Stadium. (Courtesy of the Queens Borough Public Library, Long Island Division, Joseph A. Ullman Photographs.)

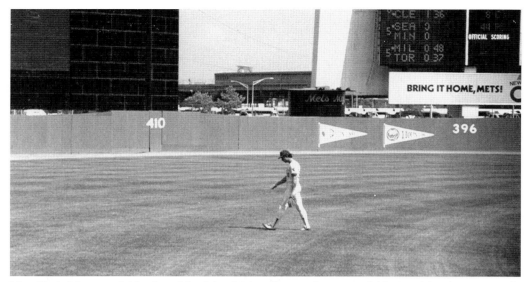

New York Mets outfielder Lee "the Mazz" Mazzilli patrols center field. Brooklyn-born Mazzilli averaged .264 and had 68 home runs, 353 RBIs, and 796 hits in his 10 seasons with the team. (Courtesy of Carl Abraham.)

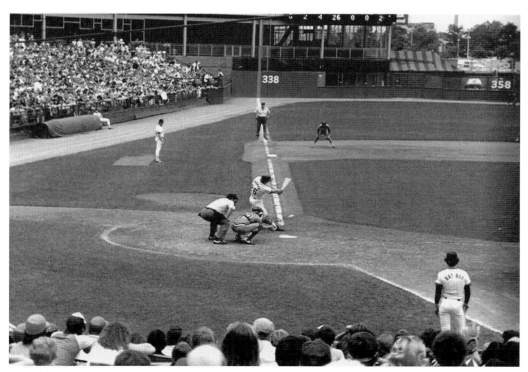

Here home run threat Dave Kingman swings and misses. (Courtesy of Carl Abraham.)

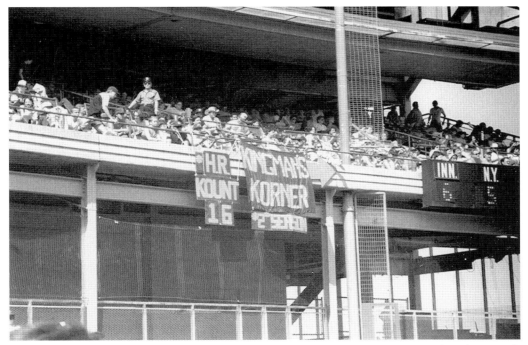

Fans set up Kingman's Korner in left field. The count is 16 home runs—so far—in this photograph from 1980. (Courtesy of Carl Abraham.)

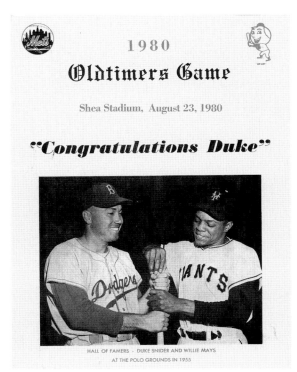

Former Mets Duke Snider (left) and Willie Mays appear on the program cover for the Oldtimers Game at Shea Stadium on August 23, 1980. (Author's collection.)

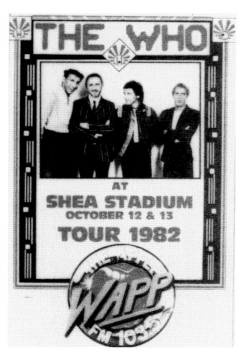

This is an official backstage pass for the Who concert at Shea on October 12 and 13, 1982. The pass was given by WAPP 103.5 FM in New York City. The event was cleverly named Who's on First? (Author's collection.)

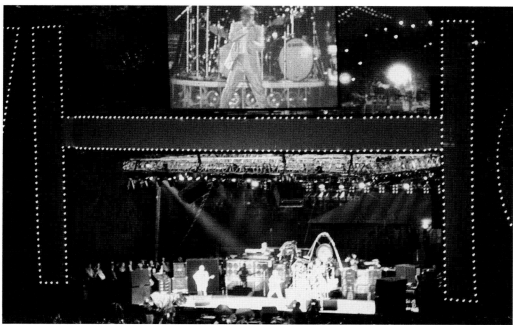

Roger Daltrey, lead singer of the British rock group the Who, appears on a giant video screen in the outfield on Wednesday, October 13, 1982, as the band toured for the last time in America. The concert would be yet another sold-out show at Shea. (Photograph by Paul Burnett; courtesy of AP/Wide World Photos.)

WPLJ 95.5 provided this backstage pass for the Police at Shea Stadium on August 18, 1983. The concert, which sold out in just five hours, also featured R.E.M. and Joan Jett and the Blackhearts. (Author's collection.)

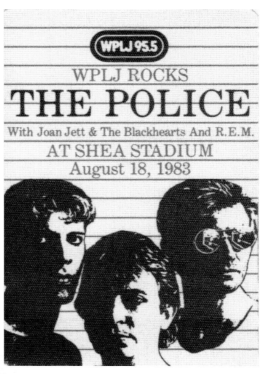

WPLJ 95.5

WPLJ ROCKS
THE POLICE
With Joan Jett & The Blackhearts And R.E.M.
AT SHEA STADIUM
August 18, 1983

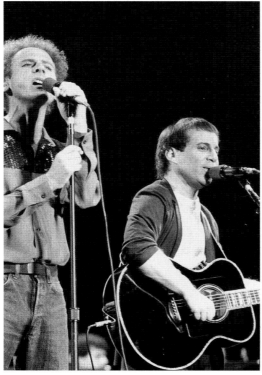

Art Garfunkel and Paul Simon perform at Shea Stadium on Saturday, August 6, 1983. This concert would be one of the duo's last. (Photograph by Dave Bookstaver; courtesy of AP/Wide World Photos.)

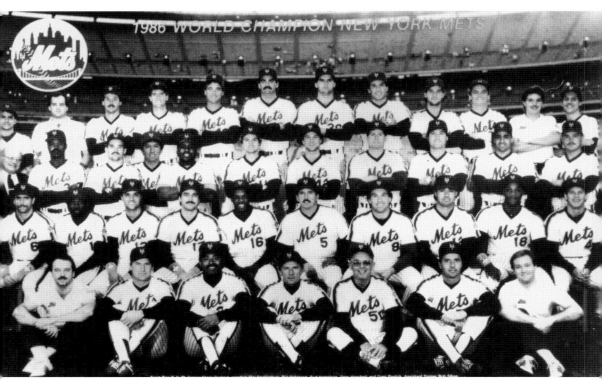

The 1986 world champion New York Mets are seen here in their team photograph. The team featured Gary Carter, Dwight "Doc" Gooden, Keith Hernandez, Ron Darling, Darryl Strawberry, Lenny Dykstra, Mookie Wilson, Howard Johnson, Ray Knight, Kevin Mitchell, Jesse Orosco, Tim Teufel, Roger McDowell, Kevin Elster, Bob Ojeda, and Wally Backman. (Courtesy of the New York Mets.)

Davey Johnson became manager of the Mets in 1985. He quickly turned the ball club around, and the team ended its season in second place. In 1986, Johnson took his team all the way. Ironically, Johnson played for the Baltimore Orioles and was the final out of the 1969 World Series. (Courtesy of TCMA Limited.)

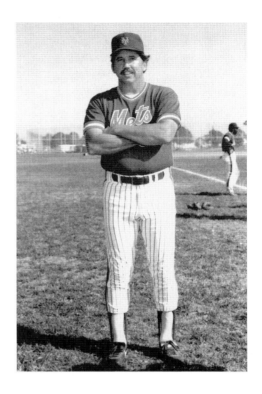

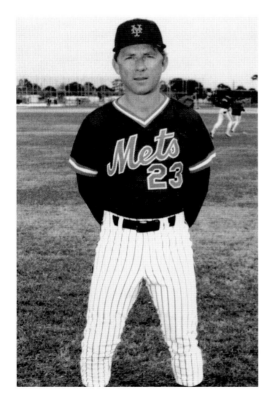

Bud Harrelson played for the Mets from 1965 until 1977. He became coach of the team from 1985 until 1990 when he replaced Davey Johnson as manager. (Courtesy of TCMA Limited.)

Lenny Dykstra, the man they called "Nails," spent five seasons with the Mets. In 1986, Dykstra hit .295 with 45 RBIs, 8 home runs, and 127 hits with 431 at bats. His most memorable moment came in Game 3 of the 1986 playoffs when Dykstra hit his game-winning walk-off home run to beat the Houston Astros 6-5 and giving the Mets a 2-1 lead in the series. (Courtesy of TCMA Limited.)

Jesse Orosco was traded to the Mets in 1979 for pitcher Jerry Koosman. He pitched the final out of the 1986 World Series. (Courtesy of TCMA Limited.)

Dwight "Doc" Gooden is one of the greatest
Mets pitchers. Traded to the Mets in 1984,
Gooden won the National League Rookie of
the Year Award. In 1985, he won the National
League Cy Young Award when he won 24
out of 35 games. (Photograph by Barry Colla;
courtesy of the Queens Borough Public Library,
Long Island Division, Portraits Collection.)

Keith Hernandez played for the Mets from
1983 until 1989. In his seven seasons,
Hernandez had 80 home runs, 939 hits, and
468 RBIs. As a first basemen, Hernandez is a
legend. He won 11 consecutive Gold Glove
Awards from 1978 to 1988; the first five were
with the St. Louis Cardinals. He was also
the Mets' first team captain. In 1997, he was
inducted into the New York Mets Hall of
Fame. (Photograph by Barry Colla; courtesy
of the Queens Borough Public Library, Long
Island Division, Portraits Collection.)

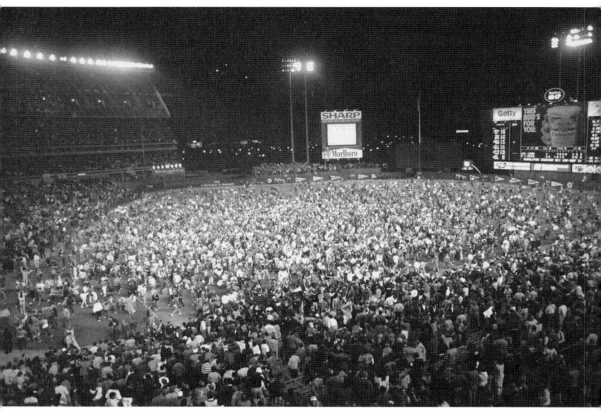

The New York Mets won the National League East by defeating the Chicago Cubs 4-2. In this amazing wide shot, thousands of fans storm the field as they wildly celebrate their team's victory on Wednesday, September 17, 1986. (Photograph by Louis Requena; courtesy of AP/Wide World Photos.)

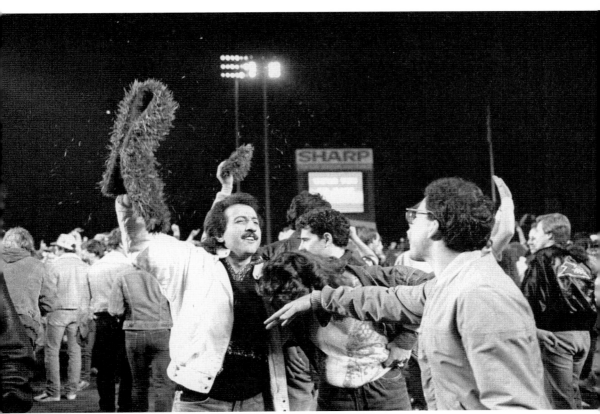

Mets fans pull up enormous pieces of the turf as they celebrate their return to the postseason after 13 years. Police could not control the crowd, which had already started pouring into the Mets dugout even before the final out! (Photograph by Susan Ragan; courtesy of AP/Wide World Photos.)

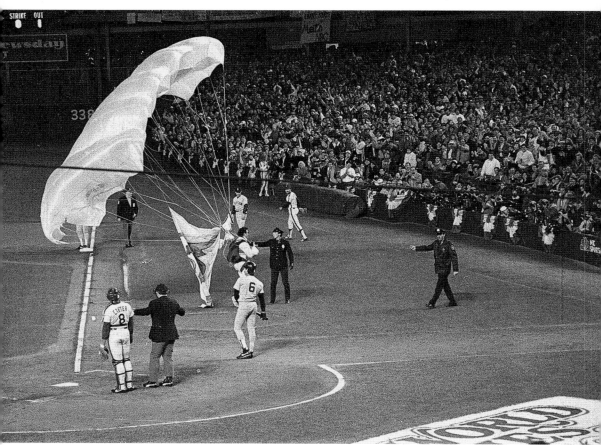

New York Police Department officers remove Michael Sergio, age 37, of New York City from the field after he skydived out of an airplane piloted by a friend. He landed with his giant parachute displaying a Lets Go Mets banner, in the infield during the first inning of Game 6 of the World Series between the New York Mets and the Boston Red Sox on Saturday, October 25, 1986. Sergio would go on to comment, "My knees were shaking more than ever." The jump was his 1,912th. "What I did was out of a feeling for love for the Mets and a feeling of fun." (Photograph by Amy Sancetta; courtesy of AP/Wide World Photos.)

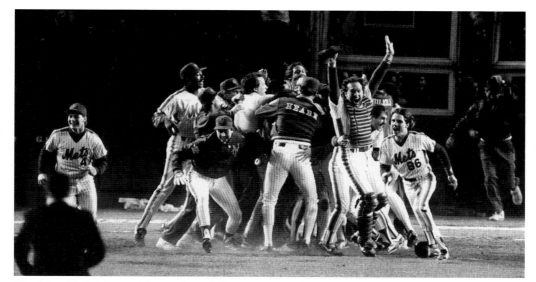

The New York Mets celebrate their 6-5 victory over the Boston Red Sox, in the 10th inning of Game 6 of the 1986 World Series. Boston was one out away from winning the championship before the Mets came from behind to win and force a decisive Game 7. Mookie Wilson's grounder passed through first baseman Bill Buckner's legs to score Ray Knight with the winning run. Who could ever forget Vin Scully's famous call? "Little roller up along first . . . behind the bag! It gets through Buckner!" (Photograph by Richard Drew; courtesy of AP/Wide World Photos.)

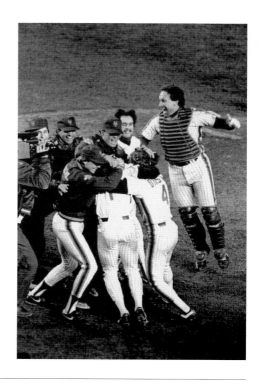

New York Mets catcher Gary Carter, right, leaps on his teammates as they celebrate the 6-5 victory over the Boston Red Sox. Carter, as a catcher, performed exceptionally at the plate. In his five seasons with the Mets, he batted an overall .249, which included 89 home runs, 349 RBIs, and 542 hits. In 2003, Carter was inducted into the National Baseball Hall of Fame as a member of the Montreal Expos. (Photograph by Amy Sancetta; courtesy of AP/Wide World Photos.)

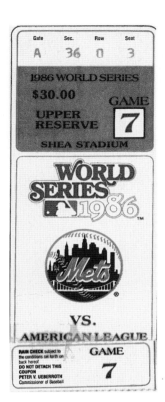

This is an official ticket for Game 7 of the 1986 World Series. The game was delayed one day by rain, exacerbating the already tense feeling in the metro area after the Mets' come-from-behind win in Game 6. (Courtesy of the Rutsky family.)

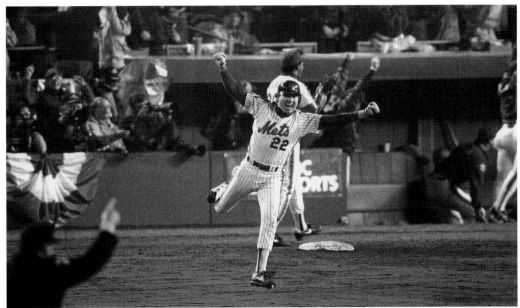

Ray Knight raises his fists in triumph as he watches the ball he just hit sail over the left field wall. The home run put the Mets ahead of Boston 6-3 in the decisive Game 7 of the 1986 World Series. (Photograph by Richard Drew; courtesy of AP/Wide World Photos.)

SHEA STADIUM'S GREATEST MOMENTS AND PLAYERS

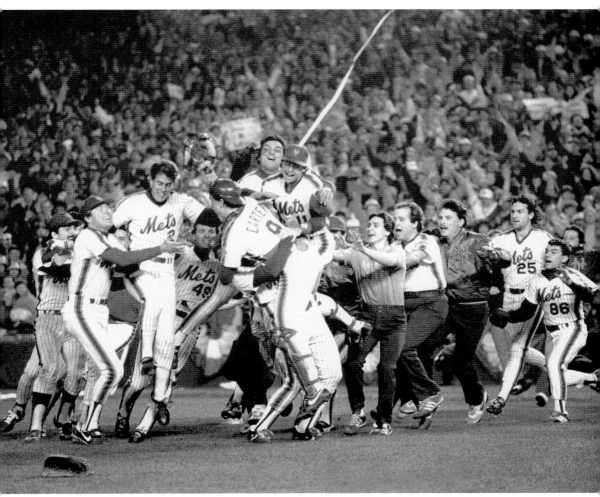

The New York Mets are celebrating their victory over the Boston Red Sox to win the 1986 World Series. Catcher Gary Carter and pitcher Jesse Orosco are about to be toppled by their teammates who rush to them. Second from left is Ray Knight, who was named MVP. (Photograph by John Roca; courtesy of the New York Daily News.)

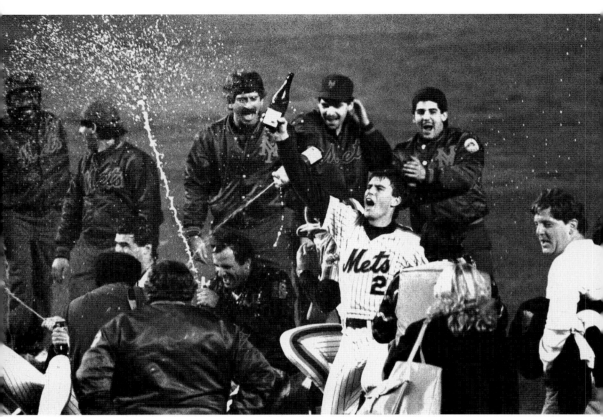

Kevin Elster and other members of the New York Mets spray champagne on the field after Game 7 of the 1986 World Series. The game ended without the traditional on-field eruption of fans. A brigade of New York Police Department officers on horseback kept the fans at bay. (Photograph by Rusty Kennedy; courtesy of AP/Wide World Photos.)

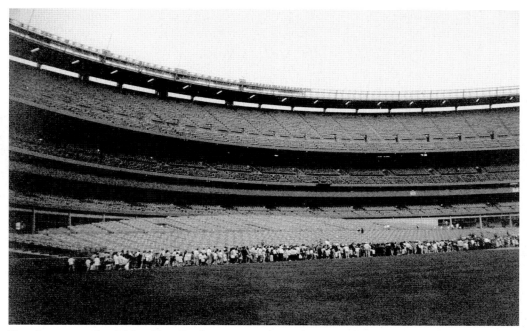

Fans line up on the field at Shea Stadium to partake in the annual DynaMets Dash, which allows children under the age of 12 to actually run the bases! (Author's collection.)

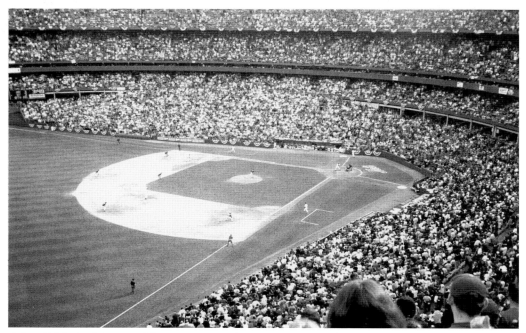

After 1988, the Mets would not return to the postseason until 1999. Here a crowd of 53,000 plus is on hand to witness the National League Division Series against the Arizona Diamondbacks. (Photograph by the author.)

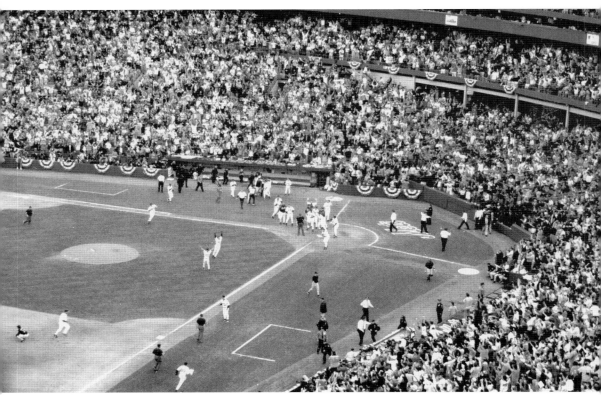

As the result of Mets catcher Mike Piazza's thumb injury, seldom-used catcher Todd Pratt was sent to bat in the bottom of the 10th inning. Pratt won the game with a walk-off home run and defeated the Arizona Diamondbacks 4-3 to move the Mets into the National League Championship Series against the Atlanta Braves. Here jubilant Mets team members and fans go crazy at Shea Stadium as Pratt makes his way to home on October 9, 1999. (Photograph by the author.)

Fireworks explode over the outfield in celebration of the victory. The scoreboard reads, "Congratulations New York Mets on Advancing to the National League Championship Series." (Photograph by the author.)

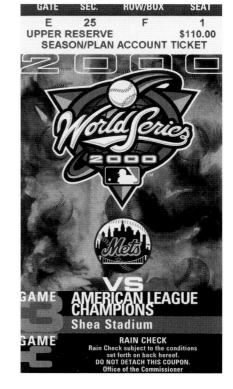

This is a ticket to Game 3 of the "subway series" between the New York Mets and the New York Yankees. The Mets would go on to win the game 4-2 but lost to the Bronx Bombers in five games. Unfortunately for Mets fans, the win happened on their home turf. (Author's collection.)

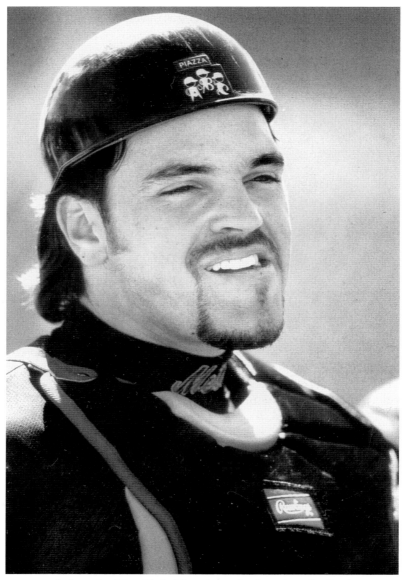

Mike Piazza was traded to the New York Mets from the Los Angeles Dodgers in 1998. Piazza helped the Mets to two consecutive playoff appearances and a trip to the World Series. One of the most emotional moments of Piazza's career came when he belted a dramatic two-run walk-off home run in the eighth inning against Steve Karsay on September 21, 2001, at Shea Stadium to lift the Mets to a 3-2 triumph over the Braves. The game was the first regular season professional sporting event held in New York City after the September 11, 2001, terrorist attacks. On May 5, 2004, Piazza surpassed Carlton Fisk for the most home runs by a catcher with 352. In his 14-year career, Piazza's career batting average is .309 with 419 home runs, 1,288 RBIs, and 308 doubles in 1,702 games. Piazza marked the beginning of a new era of Mets superstars as he led the team into the 21st century. (Author's collection.)

SHEA STADIUM AND THE FUTURE

As Shea Stadium headed into the 21st century, it faced its biggest era of change. Interleague play led the way for the first subway series against the Yankees at Shea Stadium on June 26, 1998. All three games sold out, drawing 160,740 fans, the most for a three-game series in Mets history. Three months later, the fall classic came back to Shea Stadium when the Mets faced the Yankees in the first subway World Series since 1956.

Little did anyone know while watching the 2000 World Series that the world and the city would be forever changed in just 10 months. The September 11 attacks on New York City, Washington, and Pennsylvania caused all professional sports to cease. Shea Stadium served as a relief center after the attacks. Most of the gate areas were filled with food, supplies, and makeshift lodging for the massive rescue effort. Ten days later, on September 21, the Mets returned against the Atlanta Braves. On one of the proudest nights in Shea Stadium history, 41,275 fans attended the game and saw Mike Piazza hit his game-winning walk-off home run. This was an amazing comeback for the Mets, for New York City, and for its citizens.

In 2003, plans were announced to construct the new $610 million Citi Field. The stadium was designed to have an appearance similar to Ebbets Field, including a rotunda to greet Mets fans as they enter, just like in the old days. The new ballpark built in the Shea Stadium parking lot took away 2,100 spaces. Citi Field has been designed by the internationally renowned architects of HOK Sport. The park will have seating for 45,000, making it 10,000 less than Shea Stadium. Citi Field is due to open in the spring of 2009.

As for Shea Stadium, like many other ballparks in history, it will soon have its date with the wrecking ball. Frank Sinatra sang in his old ballad, "There used to be a ballpark where the field was warm and green. And the people played their crazy game with a joy I'd never seen. And the air was such a wonder from the hot dogs and the beer. Yes, there used to be a ballpark right here."

Shea Stadium underwent major renovations in 1982, 1985, and 1987. The ballpark closed down immediately at the end of the 1981 season as can been seen in this photograph of a gated Shea. Renovations cost $36 million. The new features included 50 suites on the press box level and large blue windscreen panels. The renovations were done to increase attendance, which plummeted after Tom Seaver's departure in 1977. Shea Stadium became so desolate that it earned the nickname "Grant's Tomb." (Courtesy of the Queens Borough Public Library, Long Island Division, Joseph A. Ullman Photographs.)

This is one of the last views taken of the old ballpark. Everything from the scoreboard, to the seating levels, and even the outfield wall were all changed after the renovations were complete. (Photograph by Mitchell Reibel.)

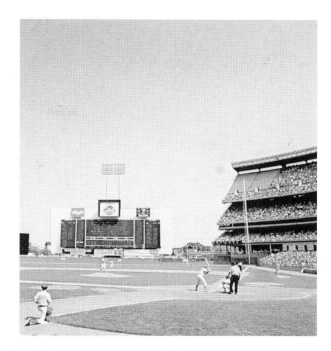

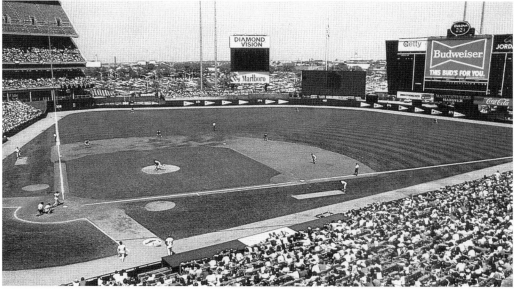

The newly renovated Shea Stadium featured the new Diamond Vision video display screen in left-center field. The screen is 35 feet 8 inches wide by 26 feet 3 inches high and shows replays, special in-game features, and statistics. The old scoreboard has also been replaced with the Budweiser sign. Below the Diamond Vision is the Marlboro Cigarettes advertisement, which caused a controversy back in the late 1980s. Also the newly added picnic bleachers can be seen in left field. At the top center of the scoreboard would appear the unique New York City skyline, which is also featured on the Mets logo. (Author's collection.)

The images of players in different poses was a new feature added onto the facade of Shea Stadium. The outlines, which replaced the old multicolored aluminum plates, were done in neon tube lighting and installed in 1988. De Harak and Poulin Associates, the graphics designer, created the six figures after famous Mets players whose identities have been kept secret. (Photograph by the author.)

A hot dog vendor walks about selling those famous ballpark franks. In 1979, Shea Stadium vendors experienced major cuts, as much as 10,000 man-hours. This was due to shrinking attendance as the Mets struggled while the first-place Yankees drew bigger crowds. (Courtesy of Nigel Caughey.)

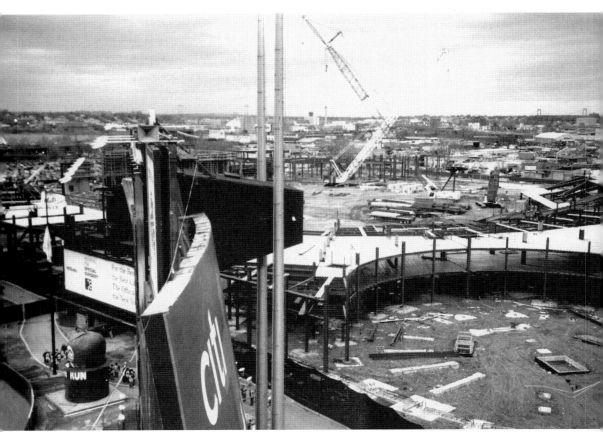

Construction of the new Citi Field began in November 2006 and is rapidly taking shape, as seen in this photograph taken on Friday, April 13, 2007. The stadium is set to open in 2009. Shea Stadium will be torn down a few months before the opening and turned into a parking lot. (Photograph by the author.)

SHEA STADIUM AND THE FUTURE

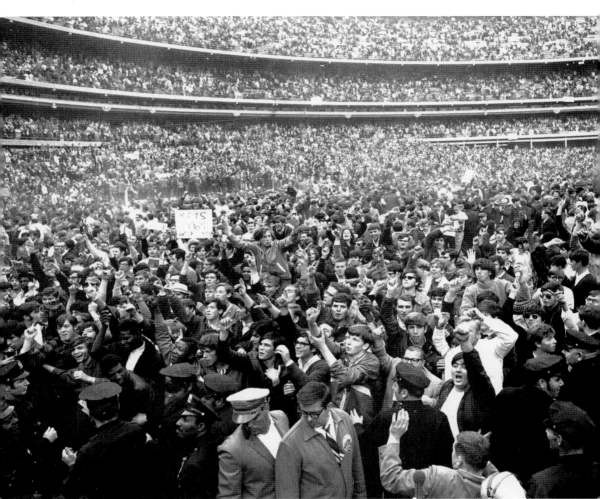

There is pandemonium as "the New Breed" storms the field after Game 5 of the 1969 World Series. Police cannot even hold back the massive crowds! And so ends this brief history of the William A. Shea Municipal Stadium. Even after the rubble is removed and new asphalt is laid down for the Citi Field parking lot, the memories of those 45 amazin' seasons will never be erased. (Photograph by Dan Farrell; courtesy of New York Daily News.)